For Wendy, Drew, Ailsa and George

 Blackburn
College

Library
01254 292120

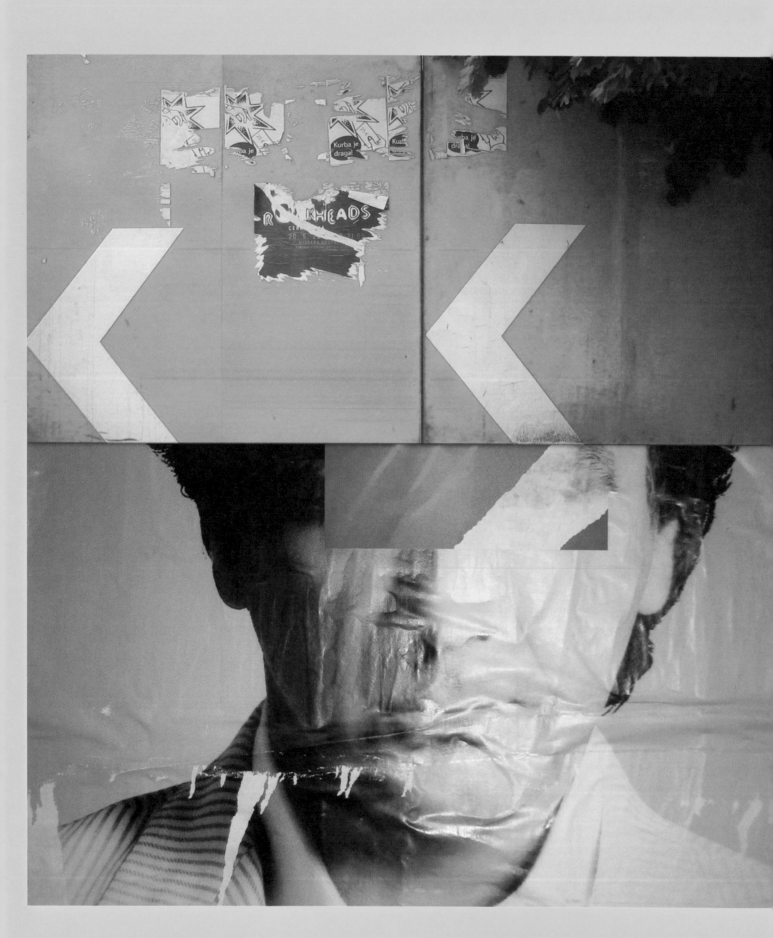

Left to Right /
the cultural shift from words to pictures
David Crow

Left

Word

Male

Verbal

Analytical

Adam

Apollo

Yang

AD

Science

Page

Right

Image

Female

Non-verbal

Holistic

Eve

Dionysus

Yin

BC

Sorcery

Screen

Contents

An AVA Book
Published by AVA Publishing SA
Rue des Fontenailles 16
Case Postale
1000 Lausanne 6
Switzerland
Tel: +41 786 005 109
Email: enquiries@avabooks.ch

Distributed by Thames & Hudson
(ex-North America)
181a High Holborn
London WC1V 7QX
United Kingdom
Tel: +44 20 7845 5000
Fax: +44 20 7845 5055
Email: sales@thameshudson.co.uk
www.thamesandhudson.com

Distributed in the USA & Canada by:
Watson-Guptill Publications
770 Broadway
New York, New York 10003
Fax: +1 646 654 5487
Email: info@watsonguptill.com
www.watsonguptill.com

English Language Support Office
AVA Publishing (UK) Ltd.
Tel: +44 1903 204 455
Email: enquiries@avabooks.co.uk

ISBN 2-940373-36-1 and 978-2-940373-36-9

10 9 8 7 6 5 4 3 2 1

Design by David Crow

Production and separations by
AVA Book Production Pte. Ltd., Singapore
Tel: +65 6334 8173
Fax: +65 6259 9830
Email: production@avabooks.com.sg

How to Get the Most from this Book

Context / Introduction

The book's subject matter is introduced at the beginning of the book as a way of helping to map the territory the book will cover.

Context / Summary

At the back of the book there is a summary of the main issues discussed in the book.

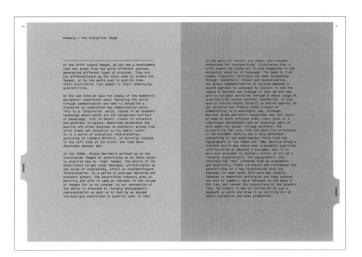

Main Text / Subheading

The main body of the discussion in each chapter is set in a serif typeface, like this one. Extended captions run alongside the illustrations and explanatory notes are included in italics at the foot of the page to explain unusual terms.

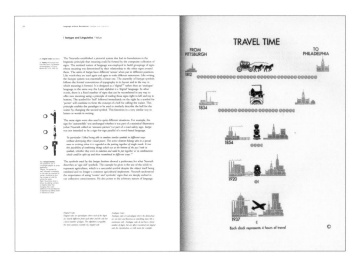

Context / Subheading

A series of short writings on contextual issues that relate to the main text is introduced throughout the book and typeset in a sans serif typeface like this one. The 'running header' that appears at the top of each page in small text next to the page number will signal if there is a context note on the page.

Captions and Footnotes

These appear in the narrow columns alongside the text.

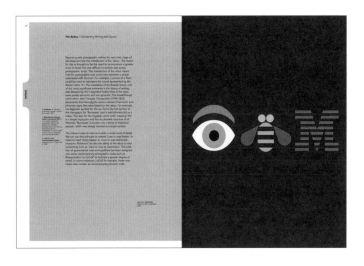

Definitions

1. **Robinson, A.** The Story
of Writing, London: Thames
& Hudson, 1995

2. **Frutiger, A.** Type, Sign,
Symbol, Zurich: ABC Verlag,
1980

3. **Elkins, J.** The Domain of
Images, Ithaca and London:
Cornell, 2001

4. ibid.

Right. In trying to separate
words from pictures we have
to accept that words are
'pictures of letters'.

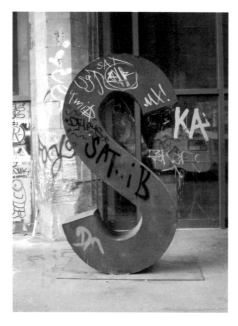

'All scripts that are full writing operate on one basic principle, (they)… use symbols to represent sounds (i.e. phonetic signs); and all writing systems use a mixture of phonetic and semantic signs. What differs is the proportion of semantic to phonetic signs. The higher the proportion of phonetic signs the easier it is to guess pronunciation.'[1]

In *Type, Sign, Symbol*[2], Adrian Frutiger suggests that there are essentially two main types of signs – pictorial and alphabetical. Pictorial scripts use pictures to represent objects, actions or ideas and it is generally agreed that there are traces of this in most alphabets. Chinese script, for example, has retained some of its pictorial nature despite evolutionary change. He describes alphabetical scripts as writing where the pictures have changed over centuries to become phonetic signs, reduced to simplified strokes and eventually to abstraction through the practice of writing. In the Latin alphabet the letter 'A' begins life as a drawing of a bull's head before eventually turning upside down to become the shape we now recognise.

Grouping signs into two broad areas of 'pictorial' and 'alphabetical' is very practical and useful, and it helps us to describe the evolution of ancient writing in general terms. Common sense would suggest that in most cases, words and images are easily identifiable. According to Leonard Shlain, the activities of reading images and reading words can be differentiated through the way that the brain behaves in each case. He describes a situation where the left side of the brain would be active in 'reading this page', but would rest while the right side of the brain engaged when 'watching images on television'. However, this apparent polarity between words and images is a fairly simplistic definition that doesn't take account of some of the complexities and subtleties at play in the act of 'reading'. In *The Domain of Images*[3], James Elkins gives a generous proportion of his fascinating book to the difficulties of classification. He lists 26 pairs of synonyms to show how poorly defined the differences are between 'word' and 'image'. Elkins proposes that the terms 'word' and 'image' could be considered inadequate as they suggest a binary polarity that plainly doesn't exist

'Any sufficiently close look at a visual artefact discloses mixtures of reading and seeing. Everyday reading and everyday looking (say, reading this page, and watching images on television) are not pure acts and so their "opposition" cannot comprise a binary pair. Any act of reading relies on a finite number of customs and strategies, and they are often at work in looking.'[4]

Certainly one can accept that letters and words are also 'images' of signs and symbols. It is an established notion that at the level of what Roland Barthes calls 'speech', as opposed to 'language', the reader is reading the way the words are represented and not just the phonetic signs. The complementary disciplines of graphic design, typography and calligraphy are almost wholly concerned with composing a form of 'speech' to read together with the linguistic message. Giving the right 'feel' to the words is a craft in itself. So one can see that despite the differences in EEG activity in the brain, it is difficult to separate word and image neatly. Elkins also discusses a three-part model that presents writing, pictures and notation as three overlapping circles with the overlaps housing other terms. Hieroglyphs, for example, would appear in the shared space between writing and pictures. In the end Elkins settles for seven subdivisions, which are listed overleaf on page 13 in the order that he introduces them. The first set of terms on page 12 is the more generally accepted and widely used.

Above. The contemporary city offers us the opportunity to communicate effectively through pictures where the words can't be understood. We are also so conditioned to words that we often find letters inside pictures of objects (above right).

Definitions / Glossary of Terms

Analogue Codes
Analogue codes are paradigms where the distinctions between each unit are not clear; they operate on something more like a continuous scale.
Music or dance, for example, could be described as analogue codes.
However, many analogue codes are reduced to digital codes as a means of reproducing them in another form. Musical notation, for example, reduces the analogue qualities of sound to distinct notes with individual marks.

Digital Codes
In *Image, Music, Text* (1977), Roland Barthes poses the question whether it is possible to have codes that are analogical. For linguists codes must be digital – that is to say that they are composed of a fixed number of digits or units. Digital codes are paradigms where each of the units in the set are clearly different from each other. The alphabet is arguably the most common example of a digital code.

Full Writing
A system of graphic symbols that can be used to convey any and all thought.

Iconic Signs
Recognisable representation of an object. A photograph of someone could be described as an iconic sign in that it is a natural resemblance of the thing it represents. It is also possible to have iconic words where the sound resembles the thing it represents. Onomatopoeic words like 'bang' or 'woof' could be described as 'iconic'.

Paradigm
The two basic characteristics of a paradigm are that the units in the set have something in common, but each unit is obviously different from the others in the set. The alphabet is arguably the most common example of a paradigm.

Pictographs
Signs that denote what they resemble.

Phonetic Signs
Signs that use symbols to represent sounds.

Phonograms
Symbols that represent one or more sounds.

Protowriting
(see also Pseudowriting)
A writing-like practice that appears to lead sequentially into full writing.

Semantic Signs
(also called logograms or ideograms)
Symbols that stand for ideas and do not denote sounds, i.e. a picture of a lion denoting bravery.

Symbols
Signs that have no logical connection between the sign and what it means. They rely exclusively on the reader having learnt the connection between the sign and its meaning. The Red Cross is a symbol that we recognise to mean 'aid'. Flags are symbols that represent territories or organisations. The letters of the alphabet are symbolic signs whose meaning we have learnt.

Terms from *The Domain of Images* by James Elkins:

1. **Allographs**
This includes calligraphy, typography, palaeography and layout. It is the sum of the changes that can be made to alphabetic shapes without losing their identity.

2. **Semasiographs**
Pictographic scripts where the images are the writing rather than on the writing (as in Allographs).

3. **Pseudowriting**
A set of signs that appears to be writing, but does not function as a record of a language or a transcription of a full system of writing.

4. **Subgraphemics**
Clear signs that fail to show any order or arrangement. These are described as being at the border of 'pure' pictures yet removed from them.

5. **Hypographemics**
Images that seem that they might be read, but lack a disjoint signary.

6. **Emblemata**
Any image that includes an explanatory text. Without the text, the image would be baffling, so the two work together to make sense.

7. **Schemata**
Images that have fewer pictures and texts, but a high proportion of notation.

context

context

context

context

++

'The increasing visual culture of 20th-century
culture reinforces the seductiveness. In the
industrialised world we are surrounded by powerful
imagery. We depend on the word, whether spoken or
printed, much less than previous generations.
Cinema, not literature has been the art form of
the century.'

Robinson, A. The Story of Writing, London: Thames &
Hudson, 1995

///

'The trend of all mass media is toward the visual
— from the fairly recent replacement of the cash
register in fast food chains and cafeterias with
computers with icons as keys, to the proliferation
of computer games…'

Seward Barry, A.M. Visual Intelligence —
Perception, Image, and Manipulation in Visual
Communication, New York: State University of New
York Press, 1997

++

Introduction

**

The rationale for this book begins with the commonly held belief that there is a shift toward the image from the written word. This is often stated in introductions to books on visual culture as an accepted feature of contemporary society and part of the context for their discussion. This book is a chance to pause on this idea and discuss it more broadly. The book is introductory in that it is not intended to be a definitive text on 'word and image' — it would be foolish to assume that the huge range of this topic could be covered in a single publication — instead the book aims to provide a series of doorways into different examples, and attempts to draw these together to form a useful discussion. The discussion is limited to 'mass' media and avoids the inclusion of the fine arts wherever possible. This is not to ignore the obvious relationship between the two cultural areas, but an attempt to limit the scope of the discussion to everyday experience.

Alongside the main discussion is a set of contextual signposts that offer the reader reference points to help them through the text. These signposts are brief historical reminders and introductions to theoretical terminology and ideas. This parallel text will also highlight the politics of language and introduce the idea that the rise of literacy played a part in the subjugation of women and that feminine thinking was suppressed wherever the alphabet appeared.

The Japanese character for 'picture' (e-on) is a construct of two symbols: the symbol for 'threads' and the symbol meaning 'to draw together'. This reference to textiles production is a typical example of how language has evolved from culturally specific roots and illustrates the close relationship between technology and language. The printing press, the camera, the television and the computer have all had an enormous effect on visual culture. I have chosen to accept the undeniably huge influence of the camera and begin the discussion just before the Second World War — a period of huge social upheaval and also the period that sees the arrival of television, arguably the single most potent technological innovation since the printing press some 500 years earlier. We will look at the debate that surrounded the introduction of the television and discuss the effect it had on other forms of mass media. Television radically changed the way we consume information and generate language. The cathode ray tube reversed the solitary practice of communication through reading, into a group activity in front of the TV: families brought together around a magic box of glowing images. We will discuss the possibility that television shifted mass communication from the left to the right side of our brain, favouring a more holistic way of reading and understanding the world: a way of reading more suited to reading images.

Alphabetic information has faced a strong challenge since the introduction of television — other types of symbolic and iconic information have begun to establish themselves as the dominant force in contemporary language. The methodical sequential thinking that characterises the reading of the printed word has been balanced out by the holistic

**
'To perceive things such as trees and buildings
through images delivered to the eye, the brain
uses wholeness, simultaneity, and synthesis.
To ferret out the meaning of alphabetic writing,
the brain relies instead on sequence, analysis and
abstraction.'/1
**

The rapid development of screen-based media over
the latter half of the 20th century has seen the
introduction of an increasingly portable range of
digital technologies and with this has come an
increasingly image-based use of language.
The convergence of the television with the home
computer, the video game, the worldwide web, the
mobile telephone and the digital camera has run in
parallel with a growing concern over the literacy
of our society. The shift away from the conventional
use of the alphabet as our principal communication
tool has challenged many of our cultural institutions
and those we might call 'language makers'. Artists,
designers, authors, publishers, schools and
universities have all had to reassess their approach
to language and find new ways of talking to a
generation that has a new way of reading.

Of course, the written word has been the primary
tool in communicating a vast range of important
ideas. Its ability to provide precision and detail
is uncanny and arguably unrivalled. However, the
pictorial world does have a number of advantages.
The ability of images to communicate across
linguistic boundaries offers a level of consistency
that is difficult to achieve otherwise. It also has
distinct cost advantages. In a global economy, the
ability to distribute the same product in a number

of territories saves both time and money. Agencies
charged with the responsibility of leaving safety
information for future generations have also opted
for images. The dangers of buried nuclear waste
are described in images on the premise that the
danger may well outlast our written language. The
ideological possibilities of a pictorial language
are unmistakable.

For designers whose practice revolves around the
design of letterforms and their application, this
has posed a particular challenge. Issues surrounding
typography have been thrown into sharp relief by
the advent of the screen-based age. By the early
1990s new digital technology was already being used
to design fonts and format them for immediate use
by others. The proliferation of type design during
this period was unprecedented, as it became the
focus of a generation of graphic designers.
Thousands of typefaces were being made, distributed,
swapped and sold. As a result the period gave birth
to the independent font companies, some of which
have now become firmly established as type design
houses. Type design became the arena for young
designers to express themselves by manipulating the
software to produce highly personal autographic
marks or create conceptual constructions of
language in a manner that owed much to the rise of

the image and the increased interest in post—modern
theory that followed. The designs were experimental
in form and many showed an entirely new conceptual
framework for typography. By this time the graphic
design courses in art schools were beginning to
adopt a new set of critical reference points
borrowed from linguistics and semiotics. A new agenda
was being formed for typography by re-examining the
relationships at the heart of language. The designer
was using the new software to create new
relationships with the keyboard. These relationships
led to a number of image—based fonts where,
for instance, typing the letter 'A' might produce
an entirely different mark from an entirely
different paradigm than the one that convention led
us to expect.

Image—makers of all kinds have grasped the
possibilities being offered by new technologies.
The range of media used in communication design
has broadened to include video, digital installation,
the worldwide web, mobile telephones and software
programming. In a post—modern landscape where the
world of commerce and the world of design borrow
and exchange ideas from each other, there is a
compelling argument that all of this is pushing
our visual culture increasingly towards the image.

**

1/ Shlain, L. The Alphabet Versus the Goddess: The
Conflict Between Word and Image, New York: Penguin
/ Arkana, 1998

The Television Age

The Arrival of Television

1. **Seward Barry, A.M.**
Visual Intelligence –
Perception, Image, and
Manipulation in Visual
Communication, New York:
State University of New York
Press, 1997

2. **Rosenberg, B** and
Manning White, D. Mass
Culture – The Popular Arts
in America, New York: The
Free Press, London: Collier
MacMillan, 1957

3, 4. ibid.

Opposite.17-inch television
set (model CS17) by Pye
Radio Ltd., a Council of
Industrial Design, Design of
the Year, 1957.
Cabinet designed by
Robin Day, circuitry
designed by **J.E. Cope**.
Image reproduced courtesy
of Design Council Slide
Collection at Manchester
Metropolitan University,
copyright Design Council.

In her book from 1997, Anne Marie Seward Barry points out that sleeping has become the only activity that children do more than watching a screen[1]. This fact is accompanied by the chilling news that the American Medical Association has cited media violence as one of the nation's public health issues. The debate about the effects of television viewing rages on unresolved half a century after the medium was introduced. If we look back to American society in the mid-1950s we can see a similar set of issues being discussed. In a review of popular arts in the United States from 1957 entitled *Mass Culture*[2] there was clearly a lot of debate about what TV had done or would do to cultural habits, particularly reading. *Mass Culture* is a critique of the effect of the introduction of television to American society in the 1950s, structured as a series of essays both for and against television as a cultural force. Marshall McLuhan's contribution describes how colonisation in the United States began when the only cultural tool available was the book. In European societies, the written word was complemented by painting, sculpture and music, but American culture associated much more with the book as a symbol of cultural knowledge. He sees it as a paradox that it is in the United States that television has had the greatest effect. Perhaps it is this dominance of the book that accounts for the swift appearance of an emotionally charged debate around the introduction of this new cultural medium.

One thing that was certain to both sides of the debate was that the birth of mass culture could be attributed to the recent technological advances. The economic climate, political system and national character could not be held solely responsible. It could never have happened without the 'most recent industrial revolution'. Television certainly took hold at a staggering pace, taking less than six years to surpass audiences for competing media. By 1955 seven out of ten homes in the United States had at least one TV set. The most frequent criticism was the loss of 'meaningful' culture and the idle behaviour that television might encourage. Gunter Anders' disparaging essay entitled 'The Phantom World of TV'[3] talks at length about the change in the way the American family would arrange themselves around the TV set in the corner of the living room. He bemoans the loss of the family table as a meeting point for discussion and exchange in a nostalgic and rose-tinted view of life before television. He proposes that there is a loss of centre with the loss of the big living-room table. Instead the family becomes an audience that arranges itself in a linear fashion 'in front' of the set and conversation, according to Anders, is accidental. With no apparent evidence he goes on to declare that the languages of all developed countries have become 'cruder and poorer'. His essay proposes that the growing inclination not to use (spoken) language is making the human experience itself poorer and cruder too. It is left to the editor, David Manning White[4], to point out that a new language was being created, driven by a new way of speaking, enabled as always by a new technology. His response uses a quotation from the 5th century BC to draw our attention to the possibility that this is simply a resistance to change.

'Our youth now love luxury. They have bad manners, contempt for authority. They show disrespect for elders and love chatter in place of exercise. They contradict their parents, chatter before company, gobble up their food and tyrannise their teachers.'
Socrates, 5th Century BC

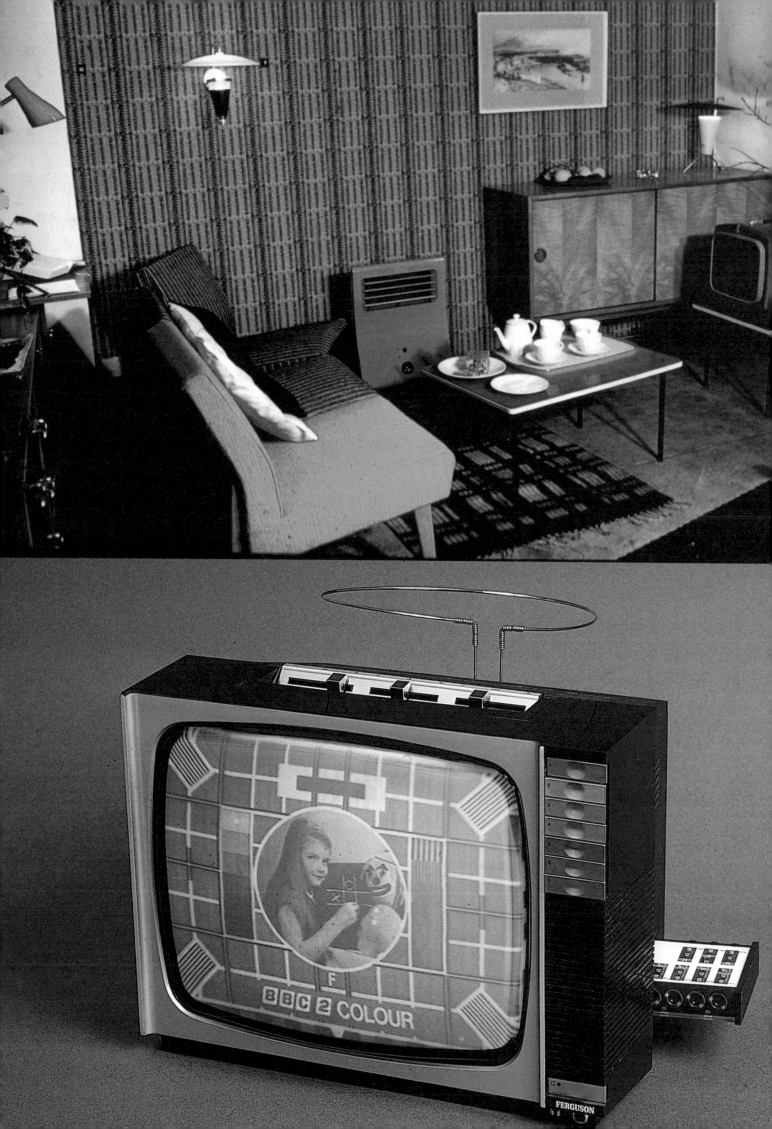

Above. Detail from an illustration in a children's encyclopedia showing television as a medium for transmitting theatrical productions, 1959.

Opposite Top. Image from the Council of Industrial Design exhibition entitled **'Design For Viewing'** at the Design Centre in London, 1957. Image reproduced courtesy of Design Council Slide Collection at Manchester Metropolitan University, copyright Design Council. The image shows how the furniture in our homes was rearranged around the arrival of the television set.

Opposite Bottom. Ferguson brand 12-inch portable black-and-white television set manufactured by Thorn Consumer Electronics Ltd., 1974. Image reproduced courtesy of Design Council Slide Collection at Manchester Metropolitan University, copyright Design Council.

5. **Rosenberg, B** and **Manning White, D.** Mass Culture – The Popular Arts in America, New York: The Free Press, London: Collier MacMillan, 1957

6. 'Sight, Sound and the Fury' in **Rosenberg, B** and **Manning White, D.** Mass Culture – The Popular Arts in America, New York: The Free Press, London: Collier MacMillan, 1957

Anders claims that the world brought into our homes by television is a debased, philistinised world where culture is reduced to a lowest common denominator[5]. Anders' version of the future sees an Orwellian television staring back at the audience, controlling its thoughts and behaviours by removing any meaningful cultural exchange. In fact in 1955 book publishing in the USA had a wonderful year and a record number of youngsters were borrowing books from public libraries.

David Manning White pointed out that television played an important role in bringing high culture to a mass audience and was responsible for whetting an appetite for culture. Lawrence Oliviers' *Richard III*, screened in March 1956, was viewed by the largest audience in the history of television to that date. More than 50 million people watched the broadcast where highbrow literature was replayed as a photographic narrative of images on a screen.

Television, and other popular media, also enabled a sharing of human experience that was not achievable through the book. Contrary to Anders' claim that television causes a spatial dislocation of any event, we find that television actually brings us closer to a deeper understanding of an event. As McLuhan put it, television has the ability to 'amplify' reality[6]. Where previously we had relied on the cathedral, the teacher or the traveller to bring us a second-hand account of current affairs, we now have a wide range of sources bringing us information at a much quicker pace. Where previously we had no choice but to trust the word of our teachers and the text from their books, we can now cross-check accounts of an event with relative ease in a range of media – television, radio, newspapers, magazines and more recently the worldwide web. In education the book created the solitary student. The earliest books had to be copied individually by each student and encouraged a contemplative and methodical, but private interpretation of the content. The book certainly did not encourage any public interrogation of the narratives they described. Marshall McLuhan describes a divorce between literature and life caused by the solitary study of text. The combination of pictorial information and the immediacy of mass media make deception much harder to achieve. It would be foolish to claim that censorship and bias have been removed from news reporting, but there is an argument that deception now needs a much more determined and strategic effort to be achieved unnoticed, even for a limited period. According to McLuhan, the technical characteristics of printing, photography, film and television all enlarge our experience and the possibilities of expression.

camera

The Influence of Television / *Magazine Case Study*

Mass Culture also stages a defence of other popular, pictorial media and recognises the significant impact of the photo-journalism of magazines like *Life*. These magazines were scorned by many critics as 'dumbing down' the media as they replaced text with pictures, content for entertainment. In a very similar way that television brought high art and officially recognised culture to the popular arena, *Life* magazine published Hemingway's *Old Man of the Sea* and the highly acclaimed series, *The World We Live In*. The use of imagery to make high culture more experiential, and ultimately more accessible, was recognised by the popular media at an early stage in its development. Mass media such as newspapers and magazines not only echoed television's ability to popularise high culture, it also became increasingly visual. The increased readership of photographic journals reflected the huge contribution that photography made to our visual palette during the war. If we look at the most everyday popular magazines published either side of the arrival of television, even here we can get a sense of the shift towards the image. The mainstream women's magazine *Woman's Own*, for example, shows a marked change in the quantity of pictorial material against text during the early part of the 20th century. However, it is the content of the advertising in the magazines that more sharply illustrates the shift from text to image.

/ Pre-television

An issue of the magazine from 1916 would carry only one full-page advertisement. The January issue for example, carried an ad on page 39 for *Icilma* cream. The ad featured a drawing of the free gift and around 250 words, including a note on how to pronounce the product name. The entire magazine was printed in one colour and was considerably smaller than the *Woman's Own* we recognise today. By 1934, although the number of pages remained roughly the same, the size of the page had increased to resemble the format we now recognise. The number of advertisements had increased significantly in the intervening 18 years and had more than doubled from 13% of the total magazine to 32.5%. The back cover page had been given over to advertising, again the image was a drawing of the product and was accompanied by 150 words of text. The inside back cover also carried advertising and in the October issue featured a full-page ad for *Lifebuoy* toilet soap with a similar word count. An *Ovaltine* ad from the November issue showed the beginnings of narrative sequencing with an ad using five narrative panels positioned around 150 words of relay text to explain the story and an additional 150 words of information – a total of 300 words of text on one advertisement.

Relay Text
This works as a complement to the image.
Relay text advances the reading of the image by
supplying meanings that can't be found in the image,
as in film dialogue.

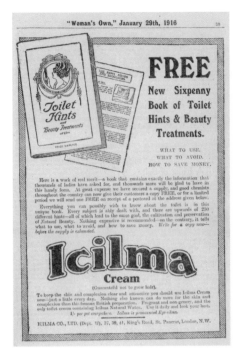

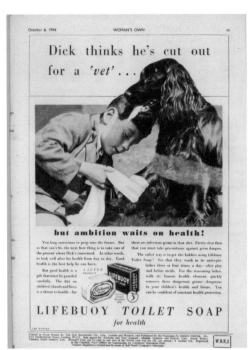

Top Left. **Icilma Cream**, full-page advertisement in Woman's Own, January 1916.

Top Right. **Lifebuoy Toilet Soap**, full-page advertisement in Woman's Own, October 1934.

Right. **Ovaltine**, full-page advertisement in Woman's Own, November 1934.

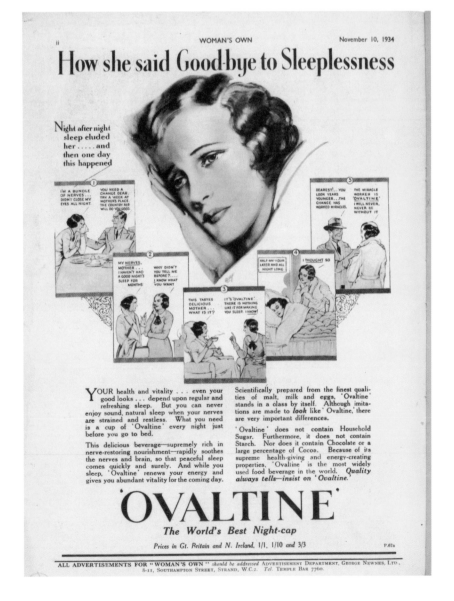

The Influence of Television / *Magazine Case Study*

/ Post-television

By 1953, television was beginning to capture the public imagination in the UK, where *Woman's Own* is published. Excitement grew around the coronation of the young Queen Elizabeth and many families used this event as an excuse to make their first purchase of a relatively expensive television set. By now, *Woman's Own* had added pages to the magazine and grown from 40 pages to 60. Perhaps not surprisingly advertisements accounted for more than half of the additional pages. The post-war period brought with it an economic drive that was reflected in the growth of the advertising industry. The balance of text to image was around 60 / 40% in the editorial with around 40% of the magazine devoted to advertising.

If we look at more 'visually led' magazines like *Picture Post*, for example, we find the balance is weighted further towards the visual with around 60% devoted to images, 20% to editorial text and 20% to advertising. Articles like *'The Road to the Throne'* (23rd Feb 1952) was essentially a photo-essay, a filmic experience displayed as a series of stills. The following month *Picture Post* carried a feature entitled *'TV's First Star Gets Married'* – a picture story that is almost a prophecy of the reality television that was to come decades later.

The front cover of the November issue of *Picture Post* in 1952 announces a feature entitled *'TV Princess'*. The young Princess is framed by a shape that mimics the television screen. The reader is presented with two celebrities, the Princess and the television. Inside we get a sequential series of screens where the event unfolds as a television show. Pictures had become the main communication media for many magazines, a phenomenon that worried many designers, as designer Ken Garland describes here:

7. **Vision 67 Design for Survival Conference**, New York, October 1967 in Garland, K. A Word in Your Eye, Reading: University of Reading, 1996

'I'm reminded of an occasion when I was the newly appointed art editor of a trade magazine. The editor thrust a few photographs into my hand and said, "Lay out a six-page feature using these." Asked what was to be the text, he told me to let him know how many column inches I would like, and they would write to fill. When I pointed out that even with the maximum conceivable amount of text there weren't anything like enough illustrations to fill six pages, he said, "Well, use your head – pick out some details and blow 'em up – give us a large fancy heading – that sort of thing."' [7]

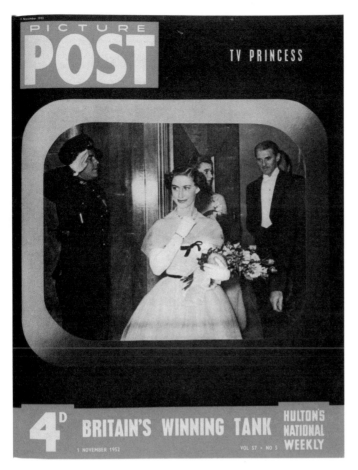

Left. **'TV Princess'**, front cover of Picture Post, November 1952.

Below. **'TV's First Star Gets Married'**, Picture Post, March 1952.

Bottom. **'The Road to the Throne'**, photo-essay in Picture Post, February 1952.

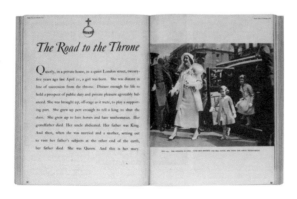

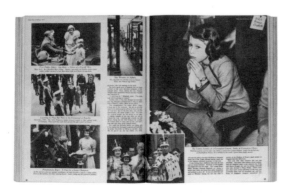

Taste the fruit!

ROWNTREE'S FRUIT GUMS

Especially when it's—

NO SMOKING
by Order

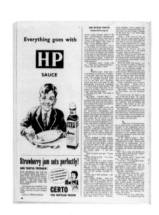

Advertisements themselves had also changed significantly. The balance of text to image in the ads had changed markedly by the early 1950s. If we look at the issue of *Woman's Own* from 1953 we can see that a full-page ad for *Kia-Ora* fruit squash on page 28 carried only three words – a huge shift from the pre-television standard of around 150 words. The image had also grown in size to cover approximately 75% of the page area. The make–up of other ads in the same issue suggests that this had become the pattern. The *HP Sauce* ad on page 40 also carried three words and the *Fruit Gums* ad on page 46 had ten words. In this instance the image covered the entire page area. An interesting feature of these ads is the way that visual metaphor had been introduced into the imagery. For example, in the *Kia-Ora* ad of June 1953 fruit is depicted as bells to associate the fruity product with the Royal Coronation in the UK – the big news event of the day. The *Rowntree's Fruit Gums* ad also shows that the visual metaphor had been introduced into advertising. The bowl of juicy fresh fruit is poured into the packet, which appears to act as a production line, turning the raw material into beautifully formed bite-sized fruity chunks – the sweets themselves. This requires a confidence from the advertiser that the audience has acquired a visual literacy that allows it to dispense with paragraphs of information. The ad doesn't call for a reasoned deliberation over why the viewer should buy the product, but functions much more around desire. It operates through what Scott Lash would describe as:

'…the spectator's immersion in, the relatively unmediated investment of his/her desire in the cultural object.'[8]

As the generation of youngsters who had grown up with television moved on to become young professionals, visual media established itself as the primary means in the media of consumption. The birth of the 'art director' and the establishment of the art director/copywriter team in advertising agencies had a huge effect. One of the most startling examples of this was the *Benson & Hedges* ads of the early 1970s created by *Collett Dickenson Pearce (CDP)*. *CDP* was considered by many to be the most creative UK agency and set the standard for the industry in the 1970s. In ads such as *Rain* or *Pyramids*, the *Benson & Hedges* pack becomes part of a celebration of visual sensation. In *Rhetoric of the Image*[9] Roland Barthes had proposed that advertising imagery could be read as a 'text', as everything was deliberate and meanings were fixed, often by the addition of words – the strapline. *Benson & Hedges* ads were quite the reverse of this traditional advertising structure. The viewer could simply enjoy the sensation of looking. The ads were what Barthes would describe as 'open signs'. There were no words nor was there any easily identifiable subtext. It was impossible to apply the accepted modernist principle of stripping away the layers of the image to reveal hidden meaning. The viewer just took pleasure in them rather than decoded them.

Opposite. **Rowntree's Fruit Gums**, full-page advertisement in Woman's Own, June 1953.

Above. **HP Sauce**, half-page advertisement in Woman's Own, June 1953.

8. **Lash, S.** Sociology of Post-modernism, London and New York: Routledge, 1990

9. **Barthes, R.** Image Music Text, London: Fontana, 1977

By appointment Suppliers of Fruit Beverages
to the late King George VI
Kia-Ora Ltd.

KIA-ORA

the **fruit** squash

MIDDLE TAR As defined by H.M. Government H.M. Government Health Departments' WARNING: CIGARETTES CAN SERIOUSLY DAMAGE YOUR HEALTH

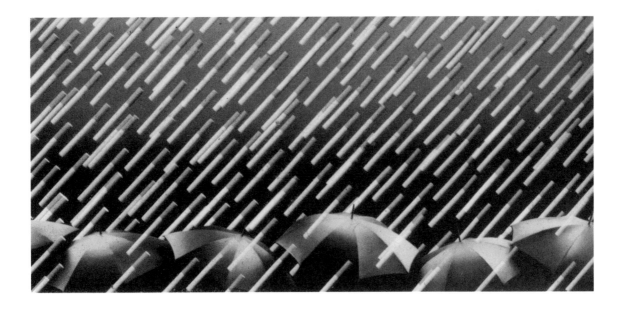

Opposite. **Kia-Ora**, full-page advertisement in Woman's Own, June 1953. The visual metaphor became a popular device for attaching particular properties and values to a product.

Top Right. **Collett Dickenson Pearce 'Pyramids'**, advertisement for Benson & Hedges.

Above Right. **Collett Dickenson Pearce 'Rain'**, advertisement for Benson & Hedges.

A New Wave

By the late 1970s the post-modern had begun to surface in British graphic design. In *No More Rules*, Rick Poynor[10] describes how graphic designers in the late 1970s were 'visual interpreters of a new mood'. This mood, according to Poynor, anticipates the economic boom of the following decade and the important part that design would play in the consumption of lifestyle products. Although LPs had been packaged with picture covers for some time, the 7-inch single was still packaged in a generic paper bag bearing the name of the record company. This all changed in the late 1970s as independent record companies realised that their audience wanted a visual experience that connected their music to their identity. The major labels quickly joined in and consuming music soon became a visual feast.

The designers assumed a level of visual literacy in their audience that gave them the confidence to use a range of 'open' signs. It was in magazine publishing and music packaging that the new sensibilities surfaced through the work of designers such as Malcolm Garrett, Neville Brody and Peter Saville. For Brody and Garrett in particular, the reference points were in Dada, Surrealism and Pop Art. Their work was full of graphic surprises and bold juxtapositions of elements and expressive typography that would grab the viewer's attention. The reference points brought with them some of the politics that underpinned them. A desire to sweep away the conventional approaches to publishing and marketing created an early critique of the globalisation of culture. However, there was no sense of a pastiche of the past. A colour palette from Pop Art would be juxtaposed with Dadaist imagery to create something unique to the new age. Peter Saville's work was perhaps more grounded in 'art direction' than that of Garrett and Brody who, as typographers, had a strong craft element in their work. Saville, described by Rick Poynor as an 'instinctive post-modernist', had an uncanny ability to capture the mood of the time. Inspired by the post-modern architecture in New York in the late 1970s, particularly Philip Johnson's *AT&T* building, Saville made what he called 'a graphic design equivalent', freely mixing classicism with modernism. It is significant that Saville's approach was a sensory approach rather than an analytical one.

'It was always an emotive feeling and after a year or so I began to trust my senses.'[11]

His packaging work in the mid 1980s for the group *New Order* pushed the visual celebration further. The record sleeves did not feature the name of the group in a brave dismissal of the accepted conventions of marketing. The sleeve for *Blue Monday*, based on the 5-inch floppy disc was a step into the conceptual that drew the viewer's attention away from the surface of the sleeve and reinforced that the sleeve was an object to be experienced. His subsequent designs for *Power, Corruption and Lies* and *Technique* also had no words on the cover. Saville referenced art history as a box of sensations to be borrowed and this was used to create what were truly extraordinary designs. The work was sensational in the true sense of the word. The imagery, special print finishes and die-cutting were all there to be explored as a sensory experience.

10. **Poynor, R.** No More Rules: Graphic Design and Postmodernism, London: Laurence King, 2003

11. **Saville, P.** Designed by Peter Saville, London: Frieze, 2003

Below. **Peter Saville,
'Power, Corruption and
Lies'** New Order, 1983.

Bottom. **Peter Saville,
'Technique'** New Order,
1989.

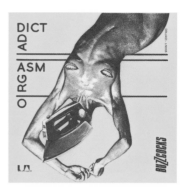

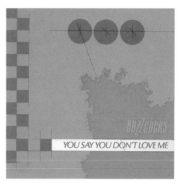

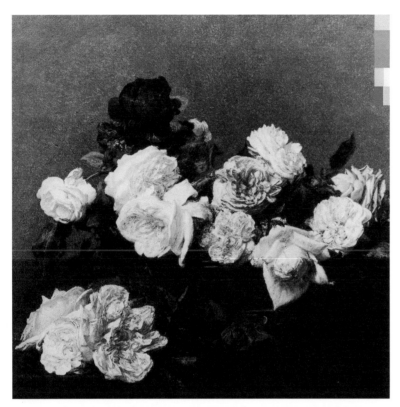

Above (from top).
**Malcolm Garrett, 'Orgasm
Addict'** Buzzcocks, 1977.
**'You Say You Don't Love
Me'** Buzzcocks, 1979.
'I Don't Mind' Buzzcocks,
1978. A playful exploitation
of the corporate nature of
music publishing. Garrett
enlarges the compulsory
requirements of the
packaging on the reverse of
the sleeve and fills the
entire sleeve with the
catalogue number and the
corporate logo. **'Product'**
Buzzcocks, a carrier bag
designed for the group
in 1978.

The sleeves did not illustrate the mood so much as they embodied it. *Power,*
Corruption and Lies features a Fantin-Latour oil painting of roses alongside panels
of colour coding that are straight from the mechanical world of reproduction.
As Rick Poynor points out:

12. **Poynor, R.** No More
Rules: Graphic Design and
Post-modernism, London:
Laurence King, 2003

13. ibid.

'It is doubtful that many New Order fans would have known much about Fantin-
Latour or enjoyed the image as an oil painting. Everything depends on the sense of
contextual displacement… Not for the first time, Saville achieved the sort of ambiguity
and complexity of resonance more usually associated with art.'[12]

Visually-led magazines had become commonplace and the volume of text gave
way to an increasing visual presence. So-called 'lifestyle' magazines offered
readers the chance to adopt a visually-led identity that could be tracked into
music, fashion, interiors and film. The borderline between economic consumption
and culture became increasingly blurred, as did the line between advertising and
editorial. Perhaps the most striking and influential example of this was *Colors*
magazine, published in the early 1990s by *Benetton* and designed by Tibor Kalman.
Colors magazine pushed powerful photography to the fore with text playing a
supporting role, usually as captions. This shift towards the image reached a
natural conclusion with Issue 13, which carries a warning on the cover that
states: 'This magazine contains no words'. The interior of this issue is a purely
photographic experience that offers the reader a rollercoaster ride through a
gallery of photographs of humanity, from images of the Earth from space to
microscopic photography.

'Pages (of Colors) had a simplicity, clarity and confidence in the communicative power of
the relatively unmediated photographic image…'[13]

Like the associated advertising campaign by Oliviero Toscani, the photographs
often featured graphic images of real situations: a newborn baby covered in
blood, a transparent body bag, a bloodstained t-shirt. Both Kalman and Toscani
forced the viewer to confront social issues in a manner that many found disturbing,
even if only on ethical grounds. It was impossible to avoid an emotional response
to the work, which fully immersed the viewer in the sensation of confronting
reality. This has inevitably led to a 'problematisation' of reality: what can now be
considered real and what are representations of the real? So-called 'ambient'
advertising campaigns embed the messages in the very fabric of the communities
they hope to influence and you can no longer rely on the word 'advertisement' at
the top of the page to help you separate an image from reality.

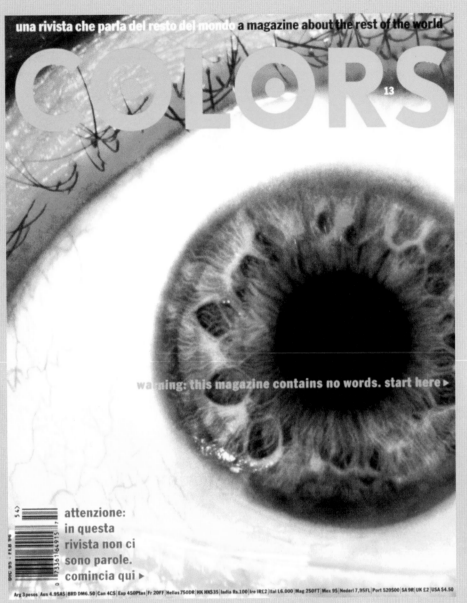

una rivista che parla del resto del mondo a magazine about the rest of the world

COLORS 13

warning: this magazine contains no words. start here ▶

attenzione:
in questa
rivista non ci
sono parole.
comincia qui ▶

DIC 95 - FEB 96

Arg 3 pesos | Aus 4.95A$ | BRD DM6.50 | Can 4C$ | Esp 450Ptas | Fr 20FF | Hellas 750DR | HK HK$35 | India Rs.100 | Ire IR£2 | Ital L6.000 | Mag 250FT | Mex 9$ | Nederl 7,95FL | Port 520$00 | SA 9R | UK £2 | USA $4.50

Colors magazine / NB. 13 / no words

Above. **Tibor Kalman**, front
cover of Colors magazine
issue 13, 1996.
This issue of the magazine
features 359 pictures and
only 442 words.

Right. Advertisement for
Benetton. Photograph by
Oliviero Toscani, Sept 1991.
Copyright Benetton Group
S.p.A. 1991.

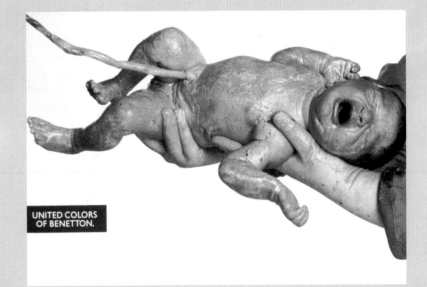

UNITED COLORS
OF BENETTON.

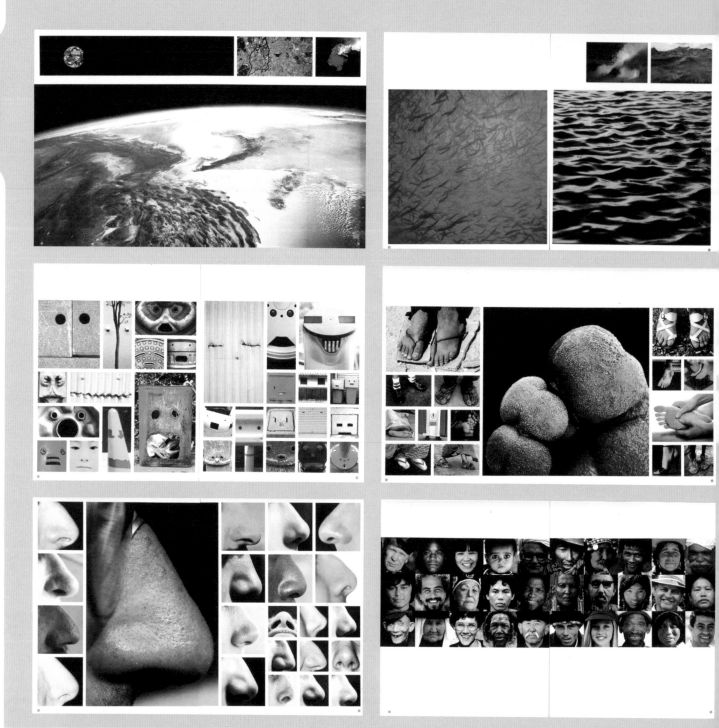

A Post-modern Sensibility

14. **Lash, S.** Sociology of Post-modernism, London and New York: Routledge, 1990

15, 16. ibid.

Left. **Tibor Kalman**, double page spreads from Colors magazine Issue 13, 1996. This issue of the magazine features 359 pictures and only 442 words.

The sociologist Scott Lash[14] offers us a theoretical structure that might help us understand the apparent shift from text to image. In essence Lash's proposal is based around a contrast between what he calls the 'discursive' modernist sensibility from the 'figural' post-modernist sensibility. During the Renaissance period it would have been difficult to separate activities like science from art or philosophy, but after the Enlightenment, areas of cultural activity began to establish some degree of autonomy and they created around them a discourse of their own. Art eventually found its way through this process and developed a discourse we might now call 'modernity', which led in turn to what we now recognise as 'modernism'. Lash calls this process 'differentiation'. Modernism gave us a way of looking at art that meant that it didn't have to be justified through some other goal.

Art wasn't merely at the service of something else such as religion or national pride, etc. Art could be discussed in its own terms and used the notion of some kind of meta-narrative as a guiding principle. Modernism rids the discourse of everything that is unnecessary in the production of art and guides the viewer to focus on the surface of the work. For example, we could cite numerous well-known paintings that are solely concerned with the surface of the canvas and are accompanied by a discussion of paintings about painting. The critic Susan Sontag famously said of this discursive sensibility for detailed interpretation that:

'...interpretation is the revenge of the intellect upon art. It is, simultaneously, the revenge of the intellect upon the world.'[15]

This 'discursive' sensibility of modernism encouraged us to search for meaning beneath the surface of things. It is based in critique as a means of explaining a culture and looks always to a systematic deconstruction of a representation. In doing so it assumes that there is somehow a truth to be uncovered in this meta-narrative, that there is more to a cultural moment than simply the aggregation of all human experience of that moment. Critic Deyan Sudjic describes the modernist designers of the early 20th century as having a:

'...Tendency to equate design and morality. They believed that decoration was reprehensible because it hid the unadorned truth they professed to find in modern materials.'[16]

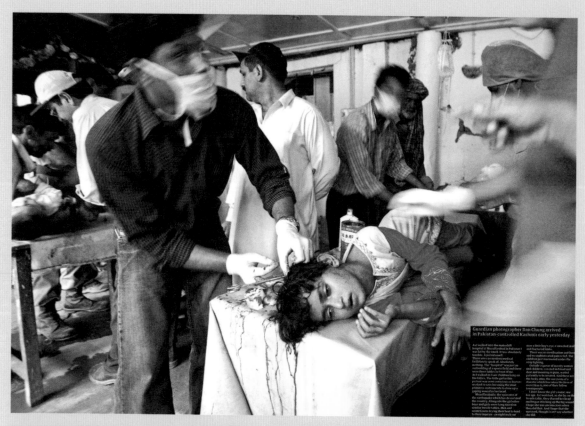

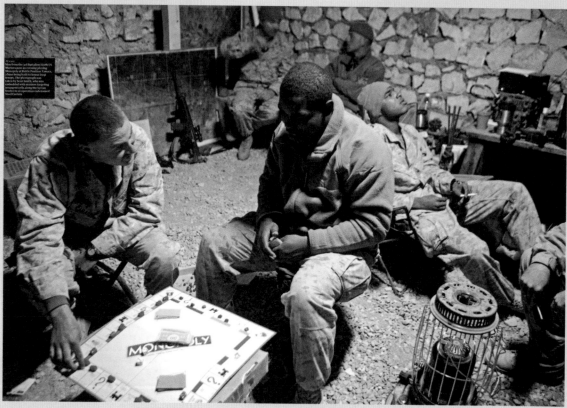

Top. Pakistan Earthquake
Victim Operation, The
Guardian, 12 October 2005
("The Content"). Copyright
Guardian Newspapers
Limited 2005.

Above. US Soldiers Playing
Monopoly in Iraq, The
Guardian, 09 December
2005 ("The Content").
Copyright Guardian
Newspapers Limited 2005.

A Post-modern Sensibility / cont.

17. **Lash, S.** Sociology of Post-modernism, London and New York: Routledge, 1990.

As a contrast to this, Lash offers the 'figural' sensibilities of post-modernism. This is a 'visual rather than a literary sensibility' that does not concern itself with formal issues and celebrates the 'signifiers of everyday life'. In its figural sensibility, post-modernism signifies 'iconically' – through images that resemble what they represent: photographs, for example. Where modernism would construct a model in which both the 'signifier' (a word or image) and the 'signified' (the meaning) are connected by the 'referent' (the object itself in reality), post-modernism would collapse this signification so that the referent becomes the signifier. In this regime, there is no search for hidden meaning, no need for purpose, just an immersion in the moment. We can simply enjoy the sensation of an aesthetic response to the experience. The figural takes everything at face value. Lash cites the Surrealists as an example of a group of artists that were truly 'post-modern':

'...not only did the Surrealists see art as being composed of signifying elements drawn from the real, but understood reality to be composed of signifying elements.'[17]

Opposite. **Guardian Newspaper,** double page spreads from the 'Eyewitness' section of the newspaper. The redesign of the Guardian in 2005 paid a great deal of attention to increasing the quality of reproduction of photographic images. This section devotes a double page spread to a powerful photographic portrayal of one of the week's most newsworthy issues.

As a result the Surrealists saw reality as a journey through a series of signifiers and sought to bring new meaning to the everyday. They sought poetic associations between these familiar objects that they saw as carrying subconscious meaning. Their use of photography as one of their principal media was a way of pulling their work back to iconic imagery as it enabled them to anchor the representation in reality.

Lash points to cinema as media where the figural post-modern sensibility is at its most visible. In the popular cinema of Hollywood blockbusters we find the sensation of the film as a spectacle is far more important than any sense of narrative structure. There is any number of action films where the plot is barely discernible, there is no sense of conclusion and the whole experience is focused on the visual experience. The figural film can also be used to question notions of the 'real'. If a cultural moment can be considered to be no more than a collective experience of that moment, then the modernist idea of differentiating the real from the constructed is called into question. Only through the figural could we find ourselves in a position where the real watch the real on television, unmediated by actors or any other form of representation. One step beyond this and we find the current position in figural post-modernism is witnessing a summary of an event on reality television as a news item on a different channel.

The Influence of Television / *Penguin Books Case Study*

18. **Baines, P.** Penguin By Design, London: Penguin Allen Lane, 2005

19. **Jan Tschichold** worked for Penguin from 1947–49 when he published the now famous Penguin Composition Rules

20. **Baines, P.** Penguin By Design, London: Penguin Allen Lane, 2005

If we look at a publishing house at the heart of UK publishing, *Penguin Books*, we can see a gradual change in approach that mirrors what was happening in other media. Phil Baines' recent overview of the cover designs of the popular paperbacks of *Penguin*[18] provides an excellent example of how attitudes shifted in post-war regeneration. Baines points out how the early designs of the 1930s were 'rooted in the traditions of the print trade' with their distinctive horizontal bands of colour and their utility typography. In fact, Penguin's production manager Edward Young designed the early covers. This 'classic' Penguin cover was retained until the early 1950s when the end of the Second World War brought new working practices and the advent of television brought new expectations from readers. Despite the elegant redesign of the covers in the late 1940s by the Swiss typographer Jan Tschichold[19], it was clear that a text-based cover would not sustain them in a new age.

The separation of cover design from book production in the 1950s was a direct response to what Baines describes as 'the increasingly sophisticated attitudes of publishers and readers towards design questions'[20]. The pre-war, pre-television paperbacks had been heavily steered towards promoting the publishers rather than the author or the book. The only part of the cover to differentiate one Penguin book from another was the cover text. However, an increasingly visually aware society was clearly able to decode a much more subtle interplay of elements and publishers' identities could be 'read' through the relationship between word and image on the cover.

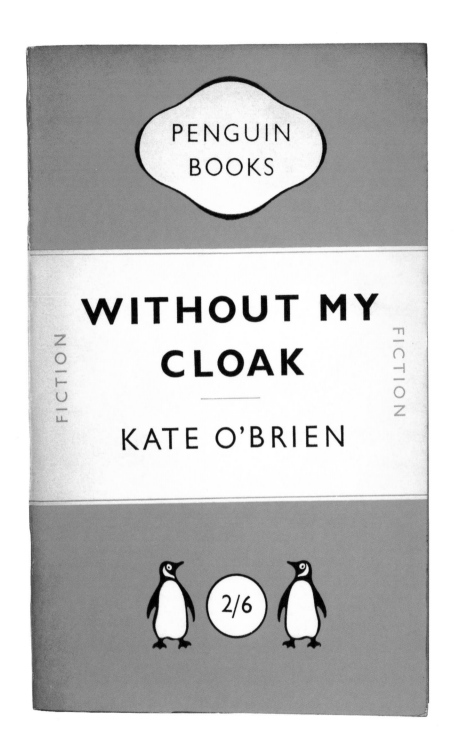

Above. **Kate O'Brien,
Without My Cloak,** 1949.
Cover showing the
redesigned typographic
front cover grid by **Jan
Tschichold**.

Penguin introduced a vertical banding to the covers. This provided a larger central white panel that could accommodate a one-colour illustration and heralded the beginning of a pictorial penguin cover. As Baines describes, there was an obvious tension between the new mood and tradition. This shows itself as an 'obvious tension' between the cover illustrations and the house grid, with the illustrations often spilling awkwardly on to the flanking orange sections of the grid. *Penguin* also began to release books that took advantage of the advent of television, and photography began to appear on the covers.

In the late 1950s Penguin decided to put the issue to a more controlled test and employed Abram Games to art direct a series of covers in 1957. Games was well known for his work during the war in the Ministry of Propaganda and for his Festival of Britain identity in 1951. Games' graphic style exemplified the mood of post-war optimism. The result was a series of extraordinarily well-conceived illustrations with a well-structured grid that also gave the publisher a clear identity. Although this 'experiment' only lasted a year, it proved to be a sign of what was to come.

In 1961 Germano Facetti was appointed as Art Editor, a move that finally confirmed the need to have an executive position dedicated to the pictorial element. Significantly, Facetti had worked in advertising as well as publishing and had helped set up *Snark International* photo library prior to this post. Facetti was part of a generation of designers who had grown up with television as a component of the social environment and he commissioned a number of other young designers who gave the imprint a distinct look and a visual consistency based on what Baines calls 'a flexible approach to Modernism'. Facetti established a new grid for the covers that would help Penguin to retain a strong identity yet could accommodate a full-bleed image on the cover. Phil Baines' book carries a quotation from Facetti that outlines his rationale for the new-look Penguin book and highlighted the importance of the image, and moving images in particular.

21. **Facetti, G.** in **Baines, P.**
Penguin By Design,
London: Penguin Allen
Lane, 2005

'The pictorial idea, be it drawing, collage or photograph, will indicate the atmospheric content of the book. The public's awareness of cinematic images offers the crime series, particularly, great photographic possibilities.'[21]

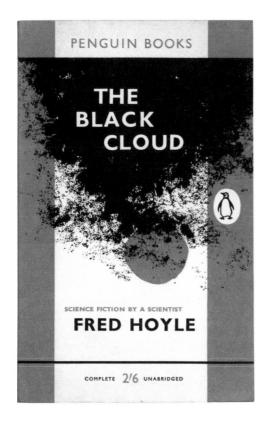

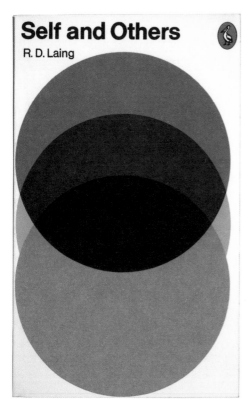

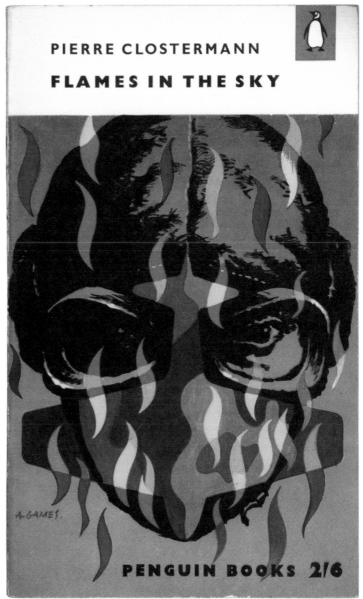

Top Left. **Fred Hoyle, The Black Cloud,** 1960. Images begin to appear over the new vertical cover grid.

Left. **R. D. Laing, Self and Others,** 1975. A more flexible grid is introduced on the related Pelican imprint to accommodate imagery. Design by **Germano Facetti**.

Above. **Pierre Clostermann, Flames in the Sky,** 1957. First experiments in introducing imagery to the covers. Design by **Abram Games**.

22. **Barthes, R.** Elements of Semiology, Cape, 1968

23. **Baines, P.** Penguin By Design, London: Penguin Allen Lane, 2005

The cover text often took a secondary role in the composition and effectively 'fixed' the signifiers in the image with the title[22] . Facetti commissioned a series of young designers and appointed Alan Aldridge as the new art director for the fiction covers. It is also significant to note that Aldridge was primarily an illustrator whose career had been focused on constructing images rather than typography. This generated mixed results as the covers often lacked coherence as a set, but importantly Aldridge ushered in the idea that the cover be given over completely to the designer. The brand consistency was secondary to the book and the author and the philosophy had turned round completely from that of the pre-war covers. The text became part of the image as the font varied from book to book and the house font disappeared altogether – an idea that continued into the 1980s.

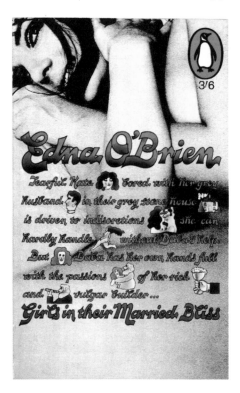

For a short period in 1989 the image took the entire front cover with the *Penguin Originals* series. The name of the title and the author disappeared completely from the cover and the only text on the cover was a panel carrying the word *'Originals'*. Whether this was a brave experiment or 'self-consciousness'[23], it certainly marks a point at which *Penguin* clearly thought that the visual cognition of its readers was so dominant that they would be prepared to accept a reading of the cover without text and search for the text elsewhere on the book. This approach had been successfully established with notable projects in brand advertising *(Benson & Hedges)* and music publishing *(New Order)*, but it proved to be less successful in this context and *Penguin* soon returned the title to the cover. *Penguin* covers today continue to be extremely visual composites. A variety of visual styles and treatments are employed that appear to target each title to a specific audience with its own visual palette. The identity of the publisher is not clearly stated on the front cover at all and the text is completely integrated into the overall visual composition in a carefully considered way. The result is often 'text as image' where the atmosphere of the content is carried by the perceived 'voice' of the lettering.

Above. **Edna O'Brien, Girls in their Married Bliss,** 1967. Design by **Alan Aldridge**.

Opposite. **Men Behaving Badly,** 1989. Design by **The Senate**, Illustration by **Dirk van Doren**.

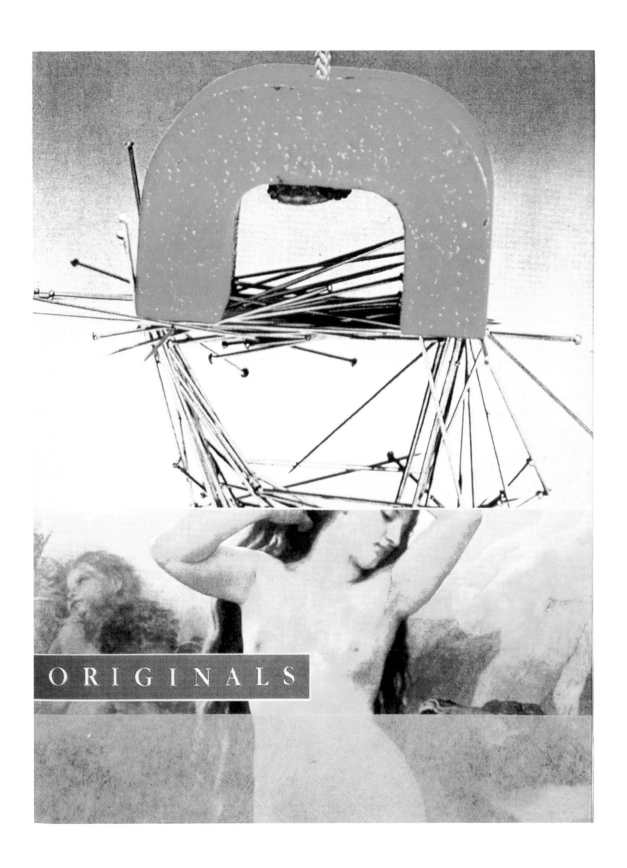

Language without Boundaries

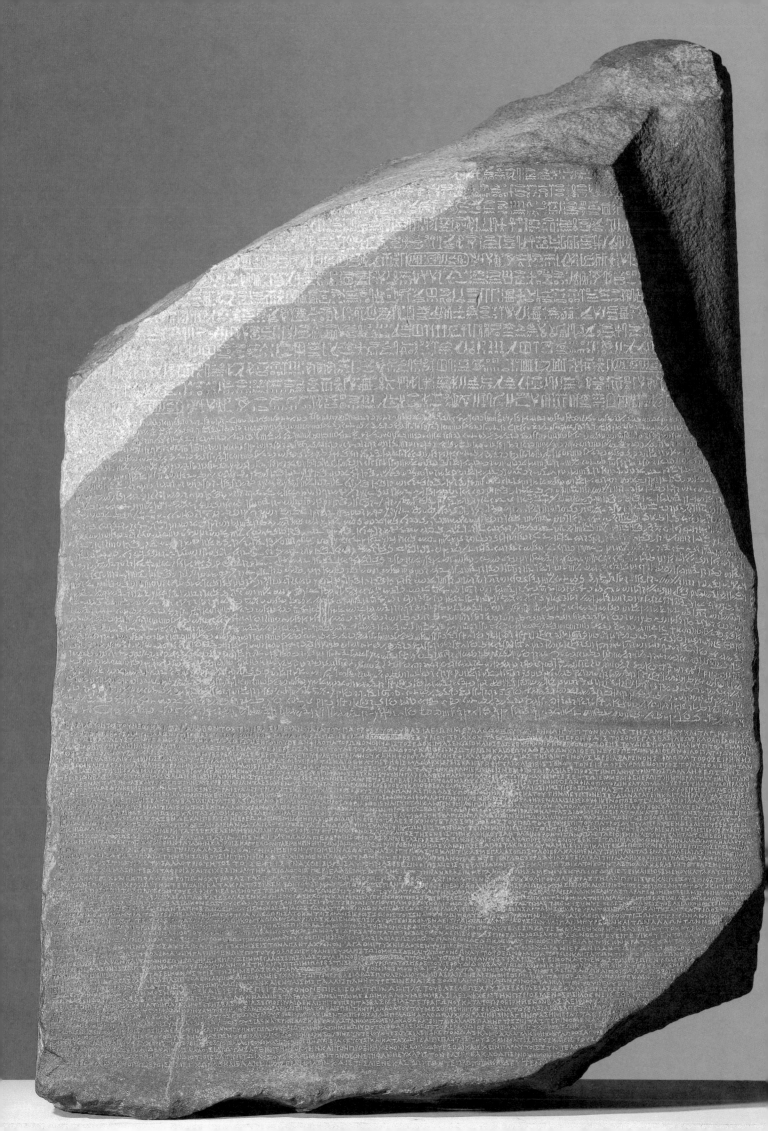

context

1. **Frutiger, A.** Type, Sign, Symbol, Zurich: ABC Verlag, 1980

Ice age wall drawings and carvings date from some 27,000 years ago. Frutiger[1] describes these drawings as 'an early attempt to visualise language' and make a record of a linguistic discourse. It is believed that the drawings were closely accompanied by a series of gestures, as an explanation or a ritual. The drawings remain as a record of these times, but the speech and the gestures have gone. The human body was often used as a reference point for these drawings through to Sumerian and Egyptian times. Man and Woman were described through drawings of genitalia or by a full figure drawing, which rendered the meaning much less obvious. These drawings are pictographic signs and can be described as 'Protowriting'.

One of the earliest uses of 'writing' is the need to make a visual record of the exchange of goods. The use of tallies and three-dimensional clay tokens were found in the Middle East from around 8000 BC. These tokens were gradually replaced with two-dimensional signs. The evidence suggests that the idea of 'writing' spread gradually from one culture to another. The earliest record of Egyptian script and Cuneiform inscriptions from Mesopotamia date from around 3100 BC, but the use of writing doesn't appear in Central America until 600 BC.

The first stage of development was the shift from 'pictogram' to 'ideogram'. This is effectively a move from straightforward iconic representation to symbolism. For example, the combination of the signs for 'Door + Ear = Spy' or 'Bull + Mountains = Wild'. This is still evident in some scripts today. In Chinese script for example, the symbol for Male = Strength + Paddyfield. This composite picture is a reflection of the historic preoccupations of the culture where the script was formed.

Paddyfield

Strength

Male

Opposite. **The Rosetta Stone**, the key to the decipherment of hieroglyphics. The stone is engraved with three scripts. At the top is Egyptian hieroglyphic script, in the middle Demotic (the cursive form of hieroglyphic) and at the bottom is Greek. The hieroglyphs were eventually deciphered in 1823 by **Jean François Champollion** (1790–1832). Champollion discovered that the Egyptian hieroglyphs were a mixture of semantic and phonetic signs based on a rebus. Image courtesy of the British Museum.

The Rebus / Connecting Writing with Sound

Beyond purely pictographic writing the next main stage of development was the introduction of the 'rebus'. The reason for this is thought to be the need to communicate a greater level of detail that was difficult to achieve with purely pictographic script. The introduction of the rebus meant that the pictographic icon could now represent a sound associated with the icon. For example, a picture of a 'bee' could be used to represent the sound represented by the Roman letter 'B'. The translation of the Rosetta Stone, one of the most significant moments in the history of writing, was delayed by the misguided fixation that all the signs were purely semantic and non-phonetic. The breakthrough came when Jean François Champollion (1790–1832) discovered that hieroglyphs were a mixture of semantic and phonetic signs that were based on the rebus. For example, the Egyptian symbol for the sun forms the first symbol of the hieroglyph for 'Ramesses' and is read phonetically as a rebus. The sign for the Egyptian word 'ankh', meaning 'life', is a single logogram and has no phonetic structure at all. Whereas 'Ramesses' is broken into a series of individual sounds, 'ankh' was simply learned as a single symbol.

The rebus is easy to read and adds a certain level of detail. We can use this principle to extend 'Love to read books' to 'Love to read Tony's books' or 'Love to read old books'. However, Robinson[2] doubts the ability of the rebus to add complexity such as 'Used to love to read books'. The addition of grammatical rules and qualifiers has been designed into some contemporary pictographic codes such as Blissymbolics[3] or LoCoS[4] to facilitate a greater degree of detail. In some instances, LoCoS, for example, these new codes also contain an accompanying phonetic code.

2. **Robinson, A.** The Story of Writing, London: Thames & Hudson, 1995

3. **Blissymbolics Communication International (BCI)** is a non-profit, charitable organisation that has the perpetual, worldwide, exclusive licence for the use and publication of Blissymbols for persons with communication, language, and learning difficulties

4. **LoCoS: Lovers Communication System** designed by Prof. Yukio Ota in 1964

Opposite. **Paul Rand,** Poster for IBM Corporation, 1981.

Utopian Ideals

5. **Robinson, A.** The Story of Writing, London: Thames & Hudson, 1995

6. **de Saussure, F.** Course in General Linguistics, London: Fontana, 1974 (first edition 1915)

7. **Robinson, A.** The Story of Writing, London: Thames & Hudson, 1995

Top.
Otto and Marie Neurath.

Above. The Isotype Institute symbol used to identify their work.

Opposite. Photographs of a travelling exhibition from the Museum of Economy and Society, Vienna.

The 17th-century philosopher, Gottfried Wilhelm von Leibniz was the first to imagine a contemporary full writing system where images could be used to describe all human communication. This writing would be free of the need to translate speech and independent of the alphabet. Such a writing system could operate outside the normal territorial boundaries of politics. This system would be more like musical or mathematical notation. If music can be described as a series of graphic marks without recourse to phonetic symbols, then why can this not be extended to other forms of the human experience? After all, music is widely recognised as having an international appeal and can be understood and appreciated all over the globe. There is of course plenty of scepticism about this idea. It is described by some as a 'romantic notion'[5] based around a fascination with the mystical nature of Eastern culture. Others see it as a linguistic impossibility. Certainly the structural view of the relationship between thought and sound suggests that this idealistic notion is not achievable. Saussure[6] describes language as a sheet of paper with thought on one side and sound on the other. We cannot cut the front of the sheet without cutting the back at the same time. Sound and thought cannot be divided. In his compelling historical overview entitled *The Story of Writing*, the critic and author Andrew Robinson reaffirms this view.

' ... *full writing cannot be divorced from speech; words, and the scripts that employ words, involve both sounds and signs.*'[7]

The accepted linguistic approach is that pictograms lack something and that something is sound. The signs are in effect too 'open'. The argument follows that they are imprecise and they lack clarity and detail. Their interpretation is left to the sensibilities and cultural background of the reader and consequently their meaning is likely to change from reader to reader.

/ Isotype Institute / 1941–1969

In the early 1920s the Viennese philosopher and social scientist Otto Neurath began work on a system of pictorial representations that came to be known internationally as '*the Vienna Method of Picture Statistics*'. Neurath had taken the role of Secretary General of the Austrian Association of Co-Operative Housing and Garden Allotment Societies at the end of the First World War. Shortly after taking on this role, the Association staged a Housing and Gardening exhibition showing improvements to food housing. Neurath wanted to create an exhibition that could be easily understood by people from the entire breadth of Austrian society and began work on a pictorial system that could be used to communicate in a way that was both visually appealing and accessible. So popular were his visual displays of public information that the Municipality supported his suggestion to establish a permanent collection of social material. *The Museum of Economy and Society* was founded in 1923 displaying a wide range of social information as pictorial displays. Its first exhibition in 1925 on Viennese Hygiene was a huge success and similar displays were soon on order from a number of Austrian social bodies that funded the museum.

N/490 (Wanderausstellung des Gesellschafts und Wirtschafts=
museums in Wien-transportable Ausstellungskojen.)

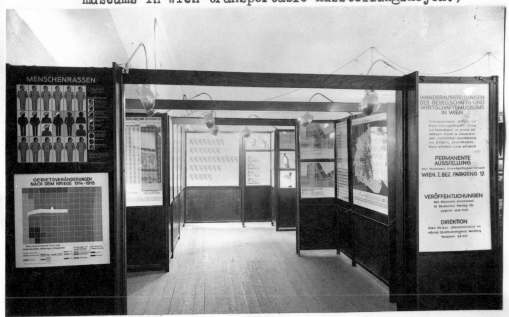

N/491

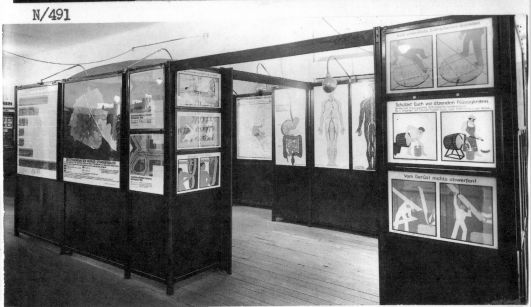

DIAPOSITIV VORHANDEN.

N/492 (Karte von Oesterreich-Magnetkarte)

8. **Neurath, O.** International Picture Language, London: Kegan Paul, Trench, Trubner & Co., 1936

9. **Neurath, M & Lauwerys, J. A.** How the First Men Lived, Parrish, 1951

10. **Neurath, M.** What is Electricity?, Parrish, 1964

11. **Neurath, M.** What's New in Flying?, Parrish, 1957

The following year Neurath strengthened the team with the addition of illustrator Erwin Bernath, bookbinder Joseph Scheer, and graphic artists Bruno Zuckermann and Gerd Arntz. By the end of the 1920s the museum was designing pictorial displays for clients in a number of foreign countries including exhibitions in Berlin, Dusseldorf, Amsterdam, The Hague and Chicago. The so-called *'Vienna Method'* had become an international success. In 1931 Otto Neurath was invited by The Russian Embassy to found a similar social museum in Moscow, a project that lasted four years until the political climate of Austria forced him to leave the country and settle in The Hague along with his first wife Olga, Marie Reidemeister and a number of other members of his team from Vienna.

In 1936 Otto Neurath published the book *International Picture Language*[8], a detailed overview of his system, which was renamed the *International System of TYpographic Picture Education*, or *ISOTYPE*; a name suggested by Marie Reidemeister (who would later become Marie Neurath). The new name was intended to reflect the international philosophy of this new system.

Again politics caused the Neuraths to move on and in 1941 they had little choice but to flee to England to escape the advance of National Socialism in mainland Europe. It was in Oxford that Otto and Marie Neurath founded the Isotype Institute with a declared aim of 'the international promotion of visual education', particularly for children and underdeveloped countries. Together, Otto and his wife Marie constructed a collection of symbols of people, places, objects and actions that were used to enhance textbooks, posters and other educational material. During the Second World War they were employed by the Ministry of Information to produce films, leaflets, posters, charts and books. Marie Neurath continued this work after her husband's death in 1945 through the Isotype Institute. Marie devoted her energies to the design of educational books and from 1948 to the early 1970s had designed several series of highly visual books dealing with a huge diversity of topics. This ranged from standard histories, such as *How the First Men Lived*[9], to science books like *What is Electricity?*[10] and the futuristic *What's New in Flying?*[11].

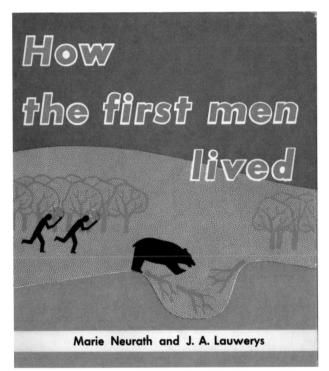

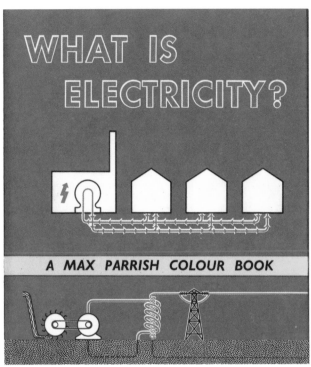

Man Comes on the Scene

All creatures which had lived during the hundreds of millions of years before man came had been content to let themselves fit into the world. Man not only tried to fit himself into the world, he also tried to alter things in the world around him so that they might suit *him* better.

When long ages of intense cold came and thick ice covered much of the earth, some men moved away to warmer places. Some found shelter in deep caves. They began to use fire to keep away wild beasts, such as the giant woolly mammoth, while they slept. Instead of always running from such creatures in fear, men gradually learned to hunt and kill them, using their skins for clothing and their flesh for food.

The top picture shows the earth before man appeared.

Then man came, learned to find food, farm, and build.

Then, about ten thousand years ago, the last ice age ended. Life was no longer so hard. Man made friends with such animals as horses, dogs, cows and sheep, training them to help him and giving them food and shelter in return. Besides gathering wild fruits, berries and herbs, men slowly learned to dig, sow seeds and reap crops.

As the years passed by, people had time for other things besides just trying to find enough food to keep them alive. Forests were cleared, large fields ploughed and planted, houses, temples and churches built.

At last man learned to make coal, steam, electricity and oil do work for him. He built railways, locomotives, roads, motor cars and great cities. He had become the kind of person we know today.

6

7

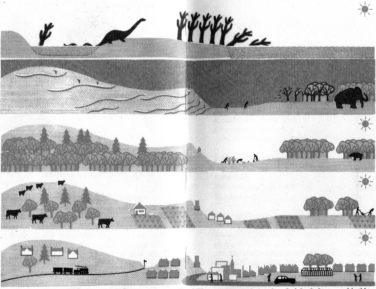

Top Left and Bottom. **Marie Neurath,** How the First Men Lived, Parrish, 1951.

Top Right. **Marie Neurath,** What is Electricity?, Parrish, 1964.

Getting Up to Great Speeds

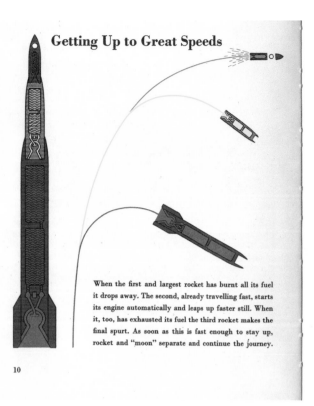

When the first and largest rocket has burnt all its fuel it drops away. The second, already travelling fast, starts its engine automatically and leaps up faster still. When it, too, has exhausted its fuel the third rocket makes the final spurt. As soon as this is fast enough to stay up, rocket and "moon" separate and continue the journey.

10

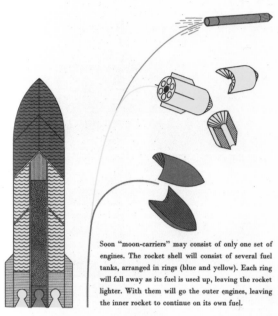

Soon "moon-carriers" may consist of only one set of engines. The rocket shell will consist of several fuel tanks, arranged in rings (blue and yellow). Each ring will fall away as its fuel is used up, leaving the rocket lighter. With them will go the outer engines, leaving the inner rocket to continue on its own fuel.

11

The First Living Space Travellers

How would space travel affect men's health? To help find out, Sputnik 2 carried a live dog. Special instruments read its pulse, breathing rate and blood-pressure, and all the readings were radioed to earth. The dog lived in an air-conditioned chamber and an automatic machine gave it food and water at regular times. The dog was strapped down to avoid injuries while the carrier-rocket soared up.

34

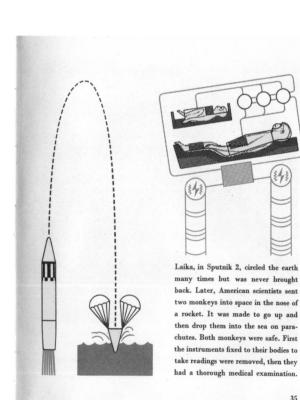

Laika, in Sputnik 2, circled the earth many times but was never brought back. Later, American scientists sent two monkeys into space in the nose of a rocket. It was made to go up and then drop them into the sea on parachutes. Both monkeys were safe. First the instruments fixed to their bodies to take readings were removed, then they had a thorough medical examination.

35

Above. **Marie Neurath,**
What's New in Flying?,
Parrish, 1957.

Two of the Strangest Machines that have Ever Flown

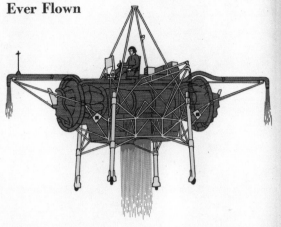

The extraordinary 'flying bedstead' has actually flown. It lands on four legs like stilts, and is driven by two jet engines at each end. The jets stream downwards from the middle of the machine and push it straight upwards. The small air jets at the sides help the pilot to keep the machine steady.

14

Here you see a pilot mounted on a round platform. Fixed to it are two engines, each of which drives a propeller. These propellers turn round in opposite directions (to keep the platform from spinning round). The pilot alters his course by moving his weight on the flying platform.

15

The Rescue Begins

The first engine is a pump-escape carrying its own tank of water, a hose and an escape-ladder. While the hose is being unrolled, the escape is wheeled into position to rescue people who may be trapped above the fire. When the fireman turns the handle the rope shown in red winds round a pulley and raises the second ladder. This ladder works a second pulley to raise the third ladder.

10

11

Top. **Marie Neurath,** What's New in Flying?, Parrish, 1957.

Bottom. **Marie Neurath,** Fire, Parrish, 1950.

N/5o3 (Ausstellung " Städtebau" Parkring).

N/5o4 (")

The Rationale for Isotype / Words Divide: Pictures Unite

Otto Neurath offered the world a pictorial language that was utopian in its desire to remove hierarchies, which are inherent in the use of written and spoken language. Isotype was an antidote to writing; an alternative or a supplement to verbal communication that would highlight our commonality rather than our differences. It was his view that we should all strive for 'greater human happiness' and his undoubted interest in linguistics centred on the idealistic notion of an international language. Neurath understood the political nature of language, so in the wake of the First World War he was keen to use language as an instrument to bring people back together. He had been interested in other experiments with universal language and his writings[12] mention *Volapük*, *Esperanto* (its successor), experiments with *Ido*, as well as the more recent attempts through *Basic English* and *Interglossa*. Neurath adopted the use of *Basic English* for the text in *International Picture Language* in 1936. Neurath saw the hierarchies of verbal language and wanted to create a system that could transcend the overtones that verbal language had acquired.

> *'In the Far East we see one language for writing, but a great number of languages for talking. We have made one international picture language (as a helping language) into which statements may be put from all the normal languages of the earth. We have given it the name "ISOTYPE".'* [13]

Neurath's fascination with ancient picture writing systems led him to a system that worked with the minimum of words. From an early age he had found pictorial languages more compelling and more immediate than words. It was these pictures that seemed to offer an opportunity to side-step the problems encountered by other attempts at internationalism.

> *'The attempt to make one international language has given us a parcel of new languages. The best way out seems to be the use of instruments which are, or have become, international.'* [14]

The work of Otto Neurath and his team grew out of what they saw as genuine social need. Like many cities at the end of the First World War, Vienna was suffering from widespread shortages. Basic resources would have been in short supply and people were living in poor quality housing with little to eat. Housing, health, social administration and education were key issues in post-war Europe and major concerns for Neurath's team. The *'Vienna Method'*, as it was called at that time, was a tool to set about the task of social reconstruction and the education of all levels of society was central to this.

12. **Rotha, P.** Future Books Vol. 2–10, from Hieroglyphics to Isotypes, Future Books, 1947–55

13. **Rotha, P.** Excerpts from Otto Neurath's unpublished Autobiography in Future Books Vol. 2–10, 1947–55

14. **Neurath, O** in **Twyman, M.** Graphic Communication through Isotype, Reading: University of Reading, 1976

Opposite. Photographs of 'City Building' exhibition from the Isotype Archive, University of Reading, UK.

The Politics of Writing

15. **Levi-Strauss, C.**
The Elementary Structures
of Kinship, Boston:
Macmillan, 1969

16. **Robinson, A.** The Story
of Writing, London: Thames
& Hudson, 1995

17. ibid.

'There is one fact that can be established: the only phenomenon which, always and in all parts of the world, seems to be linked with the appearance of writing... is the establishment of hierarchical societies, consisting of masters and slaves, and where one part of the population is made to work for the other part.'[15]

Andrew Robinson[16] points out that this is not a recent feature of writing. Even the ancient scripts (cuneiform, Egyptian hieroglyphs, Mayan script) were all used to create propaganda 'much as Stalin used posters about Lenin in the Soviet Union'[17]. They were used to reaffirm authority over a group of people and they still are. The Christian Bible tells us the story of the Tower of Babel in its first book, Genesis. The Tower of Babel is a compelling metaphor about the way that language can be used as an instrument of control, a way of establishing hierarchies that suggest one set of people is better or more special than another. Through language, one automatically identifies one's place within a social and cultural hierarchy and we all carry with us illogical attitudes about the bearers of particular language, based on our own cultural background and continued exposure to local political ideals. From the end of the 12th century, when paper-making arrived in Europe, political ideals were established through various forms of publishing. The act of publishing is still a politically charged one and remains a key element in the maintenance of a dominant discourse in whatever society the discourse exists. Publishing is one of the ways that a society imposes an authorised and official language within its political territory.

Opposite. **Marion Deuchars'** 'Comment' Guardian Newspaper, 2006. The appearance of cartoons featuring the Prophet Mohammed in Danish newspapers sparked angry, and sometimes violent protests from the Muslim community across the world. In the Muslim faith it is still considered a blasphemous act to visualise the Prophet in any way. As a result a number of newspapers censored the images despite giving the story of the reaction significant coverage.

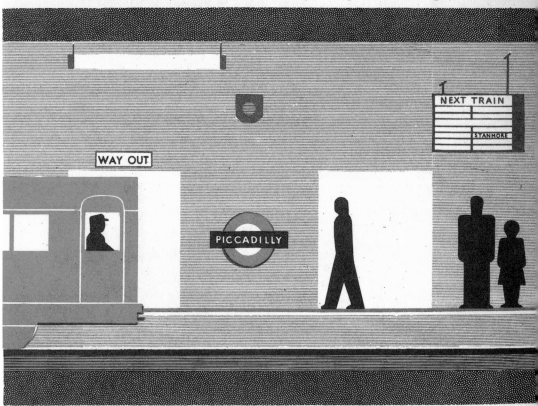

As a train approaches a station it climbs a slight slope, which helps it to slow do

18. **Rotha, P.** Excerpts from Otto Neurath's unpublished Autobiography in Future Books Vol. 2–10, 1947–55

19. **Rotha, P.** Future Books Vol. 2–10, from Hieroglyphics to Isotypes, Future Books, 1947–55

20. **Rotha, P.** Excerpts from Otto Neurath's unpublished Autobiography in Future Books Vol. 2–10, 1947–55

21. ibid.

The allegorical 'man-in-the-street' is someone central to Neurath's utopian ideals. In notes from his autobiography[18] he describes coming across the *Illustrated London News* in the coffee houses of Vienna on outings with his father. He remembers how pictures of big exhibitions were handled as social events for the aristocracy rather than as scientific successes, and his disappointment at having so much visual material and learning so little from it. His keen sense of cultural hierarchy is reaffirmed in his description of the differences between 'artistic' pictures and pictures whose first aim is to 'convey information'. He clearly has more respect for the latter in their role as 'servants of the public' and is dismissive of:

> '…the pretentious work of draughtsmen who tried to show me how steam engines worked by employing the technique of Rembrandt in an inferior manner.'[19]

Otto Neurath and his team of workers at Isotype foresaw an increasingly visual post-war world where images would play a much more important role.

> 'Communication of knowledge through pictures will play an increasingly large part in the future.'[20]

it leaves the station it runs down a steeper slope, which helps it to gather speed.

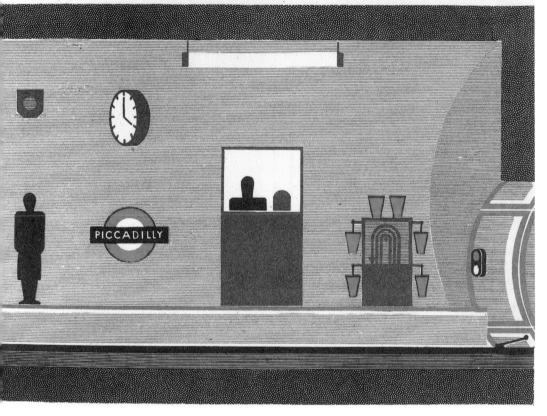

Left. **Marie Neurath.**
Illustration from Railways
under London, Adprint,
1948.

Below. **Isotype Institute.**
Visual display of births and
deaths in Vienna.

'Now is the time to
collect records of what
has been happening
visually in the last
decades. What kind
of visual impressions
have people been
absorbing, and
how have they
absorbed them?' [21]

GEBURTEN UND STERBEFÄLLE IN WIEN

The Principles of Isotype Symbols

22. **Neurath, O.**
International Picture
Language, London: Kegan
Paul, Trench, Trubner & Co.,
1936

23. ibid.

Neurath's communication system may be grounded in pictures, but its structure is firmly rooted in linguistics and its representation in typographic convention. The images were intentionally mechanical so they could be reproduced quickly and easily with no change of form.

In his unpublished *Visual Autobiography*[22], Otto Neurath describes how as Director of the *Museum of Economy and Society* in Vienna he created symbols by cutting their shapes from coloured paper to be used in the displays. This developed in to the creation of letterpress blocks so that they could be printed in a variety of colours and sizes, ready for use in hand-assembled 'paste-ups' on charts. Isotype symbols embodied a simple geometric, machine aesthetic and in doing so they paralleled the developments of the time in industrial design and architecture. Neurath travelled extensively as part of his work and was in regular contact with the *Bauhaus*. He was a personal friend of some of the leading figures in graphic design during the period such as El Lissitzky and Jan Tschichold. His use of the typeface *'Futura'*, designed in 1928 by Paul Renner, exemplified his forward thinking and his desire to visualise a language system for the future. The Isotype designers removed any reference to the craft sensibilities of the past and all trace of individual cultural dialect. This reaffirmed the democracy and international nature of their approach.

Above and Right. **Isotype Society Archive.**
A selection of original letterpress blocks and printed proofs of symbols from the Isotype Archive at Reading University, UK.

The sign 'man' has not to give the idea of a special person with the name XY, but to be representative of the animal 'man'.[23]

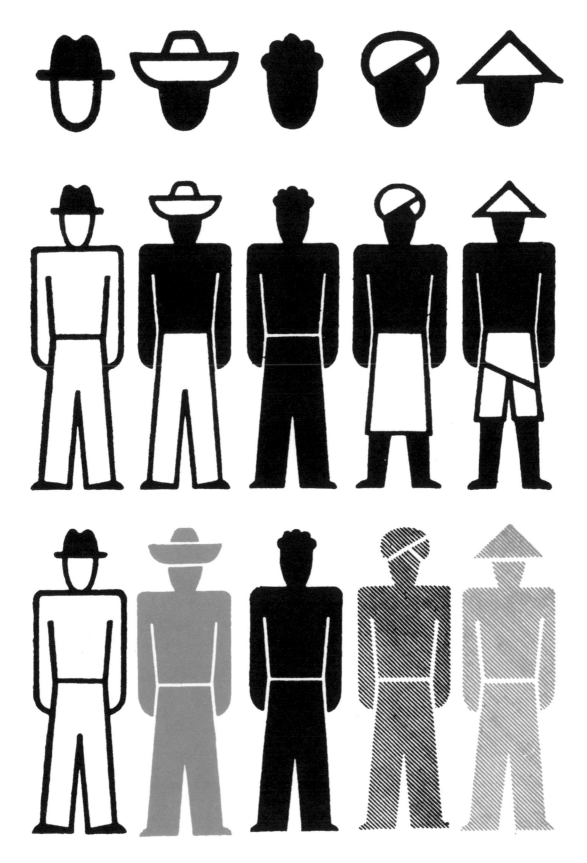

Above. **Isotype Society Archive.** Signs for the five groups of men, Isotype Archive at Reading University, UK.

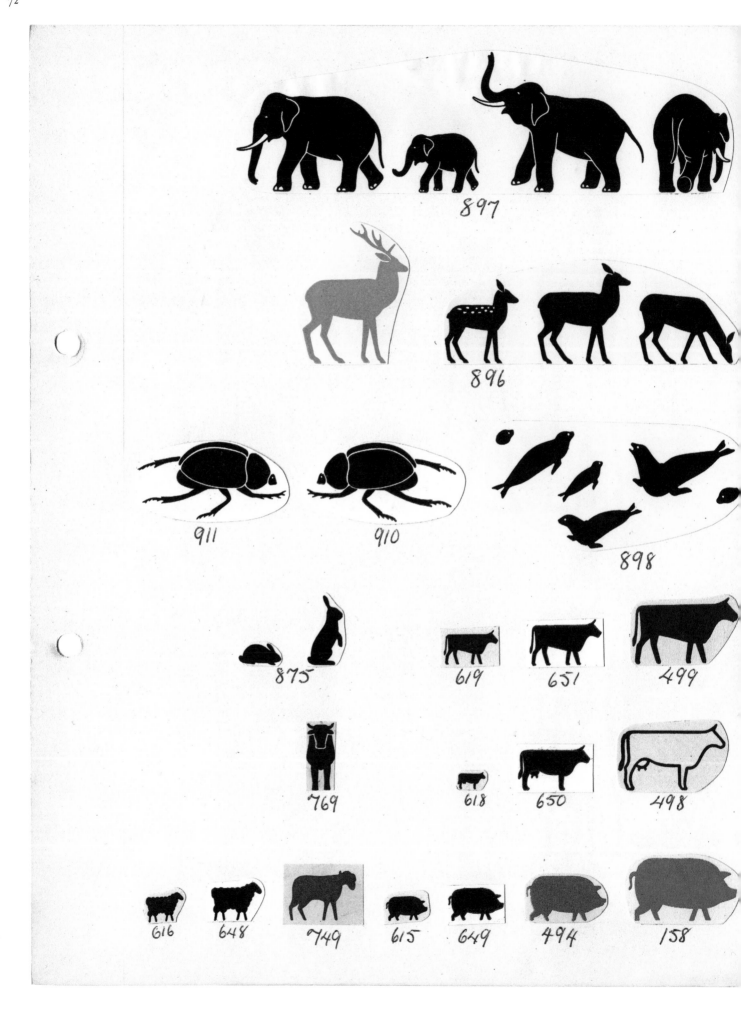

897

896

911

910

898

875

619

651

499

769

618

650

498

616

648

749

615

649

494

158

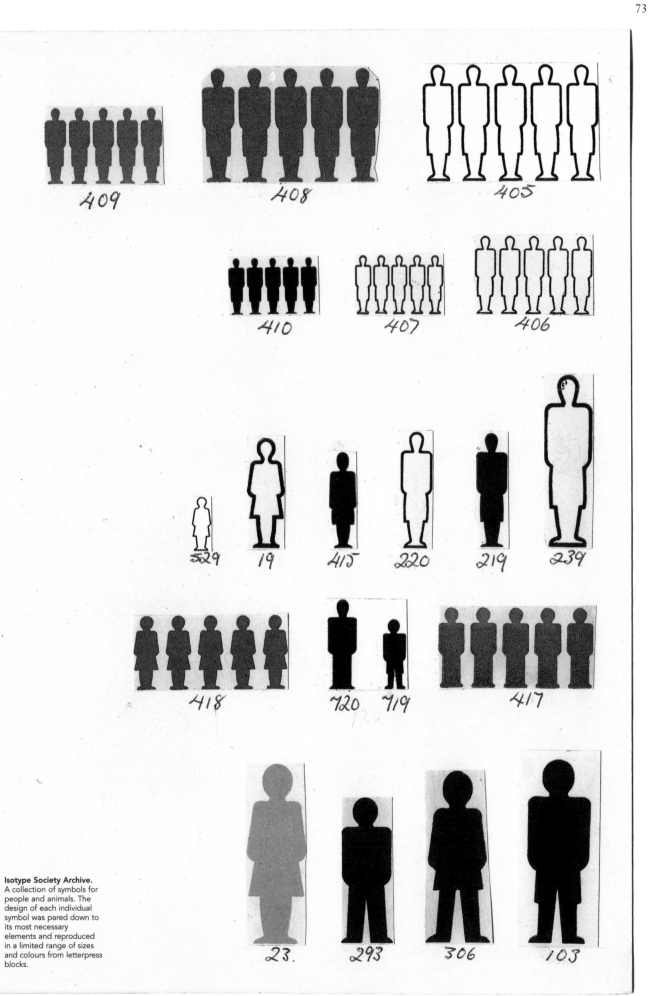

409
408
405
410
407
406
529 19 415 220 219 239
418 720 719 417
23. 293 306 103

Isotype Society Archive.
A collection of symbols for people and animals. The design of each individual symbol was pared down to its most necessary elements and reproduced in a limited range of sizes and colours from letterpress blocks.

24. **Neurath, O.**
International Picture
Language, London: Kegan
Paul, Trench, Trubner & Co.,
1936

25. **Twyman, M.** Graphic
Communication through
Isotype, Reading: University
of Reading, 1976

Despite his intention that the taste of the time would not unduly influence his symbols, we can see with hindsight that many of the signs have dated because of changes in the objects used. Although the fundamental principles of road safety signs remain largely unchanged from Neurath's version, the *Isotype* automobile is a nostalgic silhouette from a bygone age. A great deal of effort went into the design of each individual symbol and they were pared down to their most necessary elements. Neurath knew that the symbols might date and acknowledged that context played a large part in his language system:

> '...*the Isotype signs are dependent on their times like all these old sign languages.*'[24]

Despite this inevitability the signs have stood up remarkably well to the changes in context since their inception. As Michael Twyman points out in the catalogue for an Isotype retrospective in 1975:

> ' ...*the briefest survey of a selection of symbols in use today for "man" and "woman" shows how trivial and lacking in authority symbols can be when the main consideration is to look modern, and emphasises how intelligently Isotype symbols were designed.*'[25]

Above. **Marie Neurath.**
Example of the use of
Isometric perspective from
What's New in Flying?,
Parrish, 1957.

Opposite. Isotype
illustration showing the
principle of adding same-
sized symbols, rather than
larger symbols, to describe
quantity.

From its earliest days, the *Museum of Economy and Society* established the principle that quantity would be illustrated by adding a larger number of same-sized symbols rather than larger symbols. Neurath was conscious that larger symbols left you guessing at whether you were to observe increased height or area or volume. His system employs a careful yet simple logic to avoid the 'dark corners' and 'superfluities' he disliked so intensely. Colour and tone were used strategically and logically. Specific colours were assigned to specific objects and, like the Egyptian wall paintings that Neurath admired so much, men were always pictured in a darker tone to their female counterparts despite their colour or their form. The Isotype signs were mechanical in nature, using silhouettes and preferring isometric projection to perspective when illustrating depth. Neurath argues that people, children in particular, found true perspective a puzzle that was an obstacle to clear communication. He could not see any educational benefit in the use of perspective in his charts and diagrams, so he removed it in favour of isometric projection – a technique borrowed from mapping. In isometric projection objects in the foreground appear the same size to those in the distance.

oliestookinrichtingen, die het kolenscheppen overbodig maken, druk-op-de-knop-gemakken, radiotoestellen, gramophoons en filmprojectie-apparaten hebben het tehuis gemaakt tot meer dan een plek, waar vermoeide werkers slechts de behoefte aan eenige uren slaap bevredigen.

Moderne gemakken in kenmerkende inkomensklassen
Columbia (Zuid-Carolina)

$ 1-499

$ 1500-1999

$ 7000
en meer

Het aantal huizen per tien, die bezitten:
gas om op te koken electrisch licht bad of douche ijskast auto ISOTYPE

To the water

not for drinking for drinking warm water

Neurath observed that correct perspective puts the viewer in a privileged position. His keen sense of democracy was applied rigorously to all aspects of *Isotype* and his dislike for perspective drawing was symptomatic of this. Neurath's love of historic pictorial language also underlined his assertion that perspective was superfluous. In these principles are certain similarities that show a return to some of the principles of ancient writing systems. Despite Neurath's self-confessed enthusiasm for cave painting and Egyptian hieroglyphics, he would not propose that *Isotype* was part of any continuous development from the ancient systems. He points out fundamental linguistic differences such as the importance of colour in *Isotype* compositions or the *Isotype* rule of using a minimum of detail and is happy to agree with commentators and critics that *Isotype* is instead a symptom of a 'Renaissance in Hieroglyphics'.

/ Isotype and Colour

Neurath saw colour as much less problematic than the forms themselves. He was prepared to introduce flexibility depending on the number of colours available in a given situation. *Isotype* used only seven colours; white, blue, green, yellow, red, brown and black. Some of these colours could also be subdivided into light and dark. Some colours could also be mixed together if necessary. So in addition to red, they would use light red and dark red, or mix red and yellow to make orange for example. Colours were assigned special meanings dependent on the paradigm being displayed. For example, in an industrial paradigm, red was used for metal industries, blue for textiles, green for wood etc. Common sense seemed to prevail in the *Isotype* colour system. If only two colours were available (black and red, for example) in a situation where they had to show different temperatures of water, then they would simply reproduce the symbol for water and tap in red to illustrate that they were hot (see above).

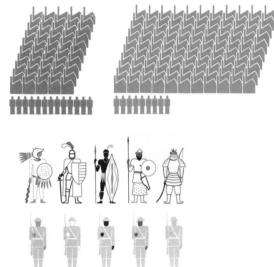

Integration—

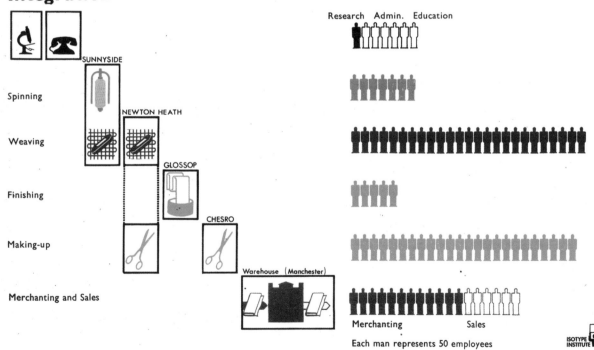

Research Admin. Education

Spinning

Weaving

Finishing

Making-up

Merchanting and Sales

Merchanting Sales

Each man represents 50 employees

Above. **Isotype Society**
Various illustrations from
Future Books, 1947–55.

/ Isotype and Linguistics / Value

26. **Digital codes** see below

27. **Rotha, P.** Excerpts from Otto Neurath's unpublished Autobiography in Future Books Vol. 2–10, 1947–55

Top. **Isotype Society**. The symbol for 'car' is unchanged despite its varied application.
Above. The symbol for 'bell' followed immediately on the right by a symbol for 'porter' combines to form the concept of a bell for calling the waiter.
Right. Quantitive value is shown by adding numbers of objects rather than changing their scale – additional time (and distance) is depicted by adding clocks or fractions of clocks.

The Neuraths established a pictorial system that had its foundations in the linguistic principle that meaning could be formed by the composite collection of signs. The unitised nature of language was employed to build groupings of signs whose meaning was determined by their relationship to the other signs around them. The units of *Isotype* have different 'senses' when put in different positions. Like words they are used again and again to make different statements. Like writing, the Isotype system was essentially a linear one. The assembly of Isotype symbols follows the formal conventions of typography in its layout and in the way in which meaning is formed. It is designed as a 'digital'[26] rather than an 'analogue' language in the same way the Latin alphabet is a 'digital' language. In other words, there is a fixed number of signs that can be recombined in any way to offer new meaning using a principle of reading those signs right to left and top to bottom. The symbol for 'bell' followed immediately on the right by a symbol for 'porter' will combine to form the concept of a bell for calling the waiter. This principle enables the paradigm to be used to similarly describe the bell for the waiter by changing the second symbol. This functions in a very similar way to letters or words in writing.

The same signs were also used in quite different situations. For example, the sign for 'automobile' was unchanged whether it was part of a statistical illustration (what Neurath called an 'amount-picture') or part of a road safety sign. *Isotype* was not intended to be a sign-for-sign parallel of a word-based language.

> *'In particular I liked being able to combine similar symbols in different ways without destroying their visual power. This active element belongs also in a special sense to writing when it is regarded as the putting together of single words. It was this possibility of combining things which was at the bottom of the joy I took in symbols, whether they were in isolation and could be put together or in combinations which could be split up and then recombined in different ways.'*[27]

The symbols used by the *Isotype Institute* showed a preference for what Neurath describes as 'age-old' symbols. The example he gives is the use of the sickle to represent agriculture, which is a successful symbol despite the object itself being outdated and no longer a common agricultural implement. Neurath understood the importance of using 'iconic' and 'symbolic' signs that are deeply etched in our collective consciousness. He also points to the arbitrary nature of language

Digital Codes
Digital codes are paradigms where each of the digits are clearly different from each other and the code has a fixed number of digits. The alphabet is arguably the most common example of a digital code.

Analogue Codes
Analogue codes are paradigms where the distinctions are not clear and function on something more like a continuous scale. Analogue codes do not have a fixed number of digits, but are often translated into digital codes for reproduction, as with music for example.

TRAVEL TIME

12

1834

1854

1920

1937

Each clock represents 4 hours of travel

©

28. **Neurath, O.**
International Picture
Language, London: Kegan
Paul, Trench, Trubner & Co.,
1936

29. **de Saussure, F.** Course
in General Linguistics,
London: Fontana, 1974 (first
edition 1915)

30. **Neurath, O.**
International Picture
Language, London: Kegan
Paul, Trench, Trubner & Co.,
1936

31. **Rotha, P.** Future Books
Vol. 2–10, from
Hieroglyphics to Isotypes,
Future Books, 1947–55

to highlight what he sees as failings in international comprehension. The Isotype man has two legs like the man it represents, while the word 'man' in any language bears no relation to the real thing. He describes the condition for a successful symbol in such a way that he paraphrases Saussure's explanation of what constitutes 'value':

'It is not only fundamental that each symbol should be clearly defined in itself; each one must also be easily distinguishable from the others.'[28]

According to Saussure the value of a sign is always composed of two things:[29]
1. A dissimilar thing which can be exchanged.
2. A similar thing which can be compared.

As we have seen, Otto Neurath was keen on connecting his work back to everyday experience. The Isotype team used observational photography to generate reference material for their work and the *Isotype Archive* at *Reading University* has boxed collections of simplified photographic narratives on everyday situations (see examples opposite).

The language of photography clearly had some effect on the use of *Isotype* symbols as the combinations of symbols show. Photography is more likely to display 'global signifiers' where a set of meanings is combined in a single non-linear composition. In this instance the individual signifiers are not distinctly separated for the viewer as they are in a linear sequence. If we look at the *Isotype* symbols we can see that the symbol for 'worker' is combined with the symbol for 'factory' by simply placing the factory on the chest of the worker. This would be read as 'factory worker'. Linguistically this form of combination is much more like photography than writing or speech. It differs slightly in the consistency of the signifiers used as they form part of a digital set like an alphabet. A photograph would combine the signifier of the factory and the worker, oil-stained overalls, for example, but might not employ 'oil' as a signifier for industry. In linguistic terms it seems that Otto Neurath and his associates at the Isotype Institute understood a variety of linguistic structures and were happy to adopt the most economic and effective structure for any given situation. For Neurath the picture language was not an attempt to replace written language:

'It has no qualities for the purpose of exchanging views, of giving signs of feelings, orders, etc.'[30]

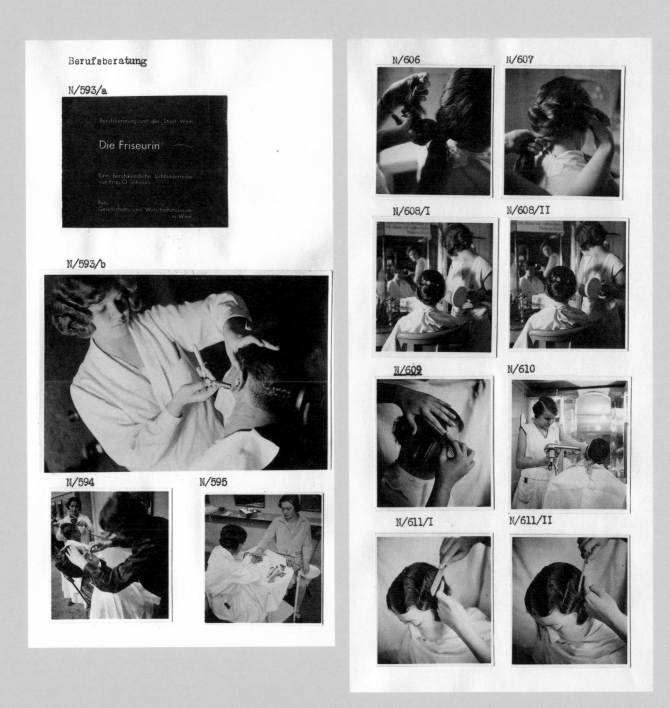

Berufsberatung

N/593/a

Berufsberatungsamt der Stadt Wien

Die Friseurin

Eine berufskundliche Lichtbilderreihe
von Frau O. Schwarz

Foto
Gesellschafts- und Wirtschaftsmuseum
in Wien

N/593/b

N/594 N/595

N/606 N/607

N/608/I N/608/II

N/609 N/610

N/611/I N/611/II

'Reading a picture language is like making observations with the eye from everyday experience.' [31]

Above. **The Hairdresser.**
A photographic narrative of
everyday events were kept
as reference material by
Neurath's team.
Photographs from the
Isotype Archive at Reading
University, UK.

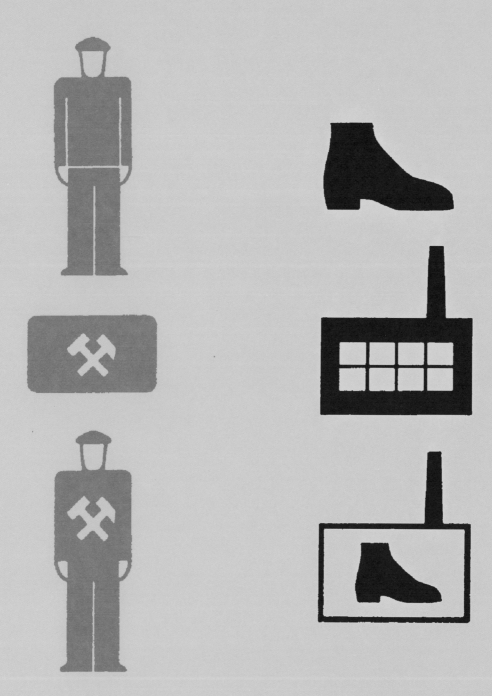

Above. Isotype symbols are combined by simply super-imposing one on the other. This changes man to worker or factory to shoe factory with the utmost simplicity. Linguistically this form of combination is much more like photography than writing or speech.

Right. Neurath's team kept an archive of photographic 'storyboards' of processes and actions. The images featured here are from an extensive collection held in the Isotype archive at the University of Reading, UK.

N/699

N/700

N/701

N/702

N/703

N/704

N/705

N/706

Blissymbolics / Semantography / The Visual Language of C.K. Bliss

32. Biography featured on **www.blissymbolics.us**, the official site of Blissymbolics Communication International (BCI)

33, 34, 35, 36 ibid.

Like *Isotype*, the story of *Blissymbolics* also starts in Vienna. The young Karl Kasiel Blitz, as he was at that time, graduated from the Vienna University of Technology in 1922 as a chemical engineer. He worked as a research chemist for an electronics company and was reportedly dissatisfied with the 'language'[32] of science. He felt that the way that it was described served as a barrier for scientific understanding and research. Language had been an important feature of his childhood. As a young boy he grew up on the Russian border surrounded by a number of confusing languages. The hierarchies of language appeared to have surfaced at school and he is quoted as describing his childhood environment as one where:

> *'Twenty different nationalities hated each other, mainly because they spoke and thought in different languages.'*[33]

His father was an electrician and his biography[34] describes how the young Charles felt more at home with the electrical symbols on his father's blueprint drawings – symbols for bulbs, switches, batteries and so on – than with the alphabet. These pictorial symbols with lines of wiring connecting them all together made sense to the young Charles as a logical language.

In 1938 the German Army invaded Austria. Bliss was sent to a concentration camp in Buchenwald and was eventually released after the efforts of his wife Claire. However, he had to leave for England immediately to avoid further persecution. The outbreak of war prevented Claire from joining him in England and it was not until 1940 that they were reunited in Shanghai – the only place that would accept both of them. In China Bliss became fascinated by the ideograms of Chinese script, although his biography says he found its complexity frustrating.

In 1946 they were granted entry to Australia where they settled and Charles began work on his system of writing that he called *'World Writing'*. Like Otto and Marie Neurath before him, he soon realised that it was necessary to give it a more international name, and he coined the name 'Semantography' from the Greek words 'semanticos', which means 'significant meaning', and 'graphein' which means 'to write'. In Sydney in 1949 he published his work *International Semantography: A Non-alphabetical Symbol Writing Readable in All languages* in three large volumes. This was a detailed explanation of his symbolic logic and semantics based on combinations of 100 symbol elements. Despite the undoubted enthusiasm of both Claire and himself the concept was met with apathy from almost all the academic community. Undeterred by the lack of interest Bliss put

together a second edition of his work, *Semantography (Blissymbolics)*, which he published in Sydney in 1965. Bliss attributes the change of name to the birth of the tourist industry. His biography quotes what seems like a rather weary and bitter Bliss after years of struggle with his project:

> *'Then something happened: the tourist explosion. Suddenly everyone realised that only pictorial symbols could bridge all languages. And equally suddenly, academic busy-bodies run (sic) to scientific foundations and asked for millions of dollars for research into the feasibility of designing a complete symbol language. They knew of my work. Either they did not mention my name and the title of my work in their papers, or they changed my term into a general term, speaking of the better semantographies they will invent, given the millions for research. In anger and unhappiness I added the term Blissymbolics to my work which these would-be plagiarists could not take over.'* [35]

In the 1970s, Shirley McNaughton, a teacher in Toronto who was seeking an alternative communication system for children with severe speech and physical impairments, adopted Bliss's work. *Blissymbolics* was found to work well with these children and a documentary film of his work was published in 1975, entitled *Mr Symbol Man*. Bliss published a book of the same name to accompany the film. As a result of this successful new use for Blissymbolics he was nominated for the Nobel Peace Prize. Alfred Nobel stated in his testament that it should be given for creative ideas that can 'foster the Fraternity of Nations'.[36]

The *Sydney Morning Herald* of Saturday, 12th June 1976, in its Honours List records that Charles Kasiel Bliss of Coogee, N.S.W., was made a Member of the Order of Australia (A.M.) for services to the community, particularly children with learning difficulties.

Above Left. The logotype for the Blissymbolics Communication International (BCI).

Above. An example of Blissymbolics. The sentence reads 'the girl's book' and is constructed of 'girl' + 'belongs to' + 'book'.

Blissymbolics / The Principles

37. **Blissymbolics Communication International (BCI)** is a non-profit, charitable organisation that has the perpetual, worldwide, exclusive licence for the use and publication of Blissymbols for persons with communication, language, and learning difficulties. BCI provides leadership worldwide to the development of the system of Blissymbolics and to its use by persons with severe speech and physical impairments

38. **The Fundamental Rules of Blissymbolics**: creating new Blissymbolics characters and vocabulary, 2004

39. ibid.

Like his contemporary, Otto Neurath, Charles K. Bliss was undoubtedly motivated by personal experience, particularly his first-hand experience of the Second World War. The fairly scant biographical details show that he had a utopian desire to remove from language the possibilities for its use as an instrument of control. He clearly recognised the cultural hierarchies at play in language, quite possibly through his own experience, and wanted to create something that could provide a workable alternative. This would be a second language that would transcend linguistic boundaries and remove the potentially divisive features of language. For Bliss, the multicultural mix that resulted from the arrival of tourism in the post-war period was proof that alternatives were needed and seems to be almost a vindication of his work. The fact that teachers of children with learning difficulties finally adopted the system appears to have pleased Bliss considerably, but it is important to note that this was never the initial intention of the project. Perhaps the final use of Blissymbolics – as an effective communication tool for children who would otherwise struggle to communicate – is vindication enough on its own and can certainly be interpreted as a successful outcome to his original desire to design something that would improve people's lives. This aspect has now been adopted as an aim of the *BCI (Blissymbolics Communication International)*[37], the new guardians, and of the language system. Blissymbolics Communication International describes the system as:

> *'A symbolic, graphical language that is currently composed of over 3,000 symbols. Bliss-characters can be combined and recombined in endless ways to create new symbols. Bliss-words can be sequenced to form many types of sentences, and express many grammatical capabilities. Simple shapes are used to keep the symbols easy and fast to draw.'*[38]

Blissymbolics is made of basic geometric shapes (circle, square etc.), additional shapes (i.e. heart, house, chair), arrows (0, 45, 90 degrees only), pointers (in four directions) and can be supplemented by Arabic numerals (123 etc.) and standard punctuation marks (.,?! etc.). The marks are arranged according to a very specific placement on a matrix square with an earthline, midline and skyline to guide placement. The space between 'Bliss-characters' and 'Bliss-words'[39] is also strictly governed. The 'Bliss-words' have spaces between them, they are arranged left to right in a linear manner and can be put together to form sentences. All of this is explained in great detail in 29 pages of guidelines published by *BCI*. *The Fundamental Rules of Blissymbolics* take the reader through a variety of technical descriptions of its construction such as 'semantic modifiers', 'privation', 'generalisation', 'constituence', 'temporality' and 'gloss'. Essentially these are concerned with the ways in which the characters are arranged in a linear fashion with various modifications made through the addition of marks above, below or immediately before the main symbols. These marks qualify the main symbol in some way, for example, to indicate that the sign should be read as in 'opposition' to its normal meaning. For example to translate 'full' to 'empty', or to differentiate 'side' from 'waist' by the addition of a pointer or the addition of an 'action' mark to differentiate 'legs' from 'walk'.

tall indicator line
indicator line / ascender limit
skyline
midline
earthline
descender limit

The 'Matrix Square'

Onion

1. feeling chair taste book knowledge

2. house hospital library

3. thanks school resource centre

4. you you (female) you (male) you (boy) you (girl)

5. friend friend friend

Above. **Blissymbolics.**
Top. The matrix square for
drawing a Blissymbol
showing the subdivisions.

1. Single character Bliss-
words with pictographic
Bliss characters such as
'chair' and 'book'.

2.&3. Multiple-character
Bliss-words.

4. Personalisation of
pronouns.

5. Personalisation of the
person character.

Blissymbolics / Linguistics

40. **The Fundamental Rules of Blissymbolics**: creating new Blissymbolics characters and vocabulary, 2004

41. **Eco, U.** The Search for the Perfect Language, Oxford: Blackwell, 1995

42. **Frutiger, A.** Signs and Symbols, New York: Watson–Guptill Publications, 1997

Below. The BCI template, 1980. The BCI guidelines state that this can be used to draw the geometric shapes used to form Bliss characters. The guidelines also add that this template 'must be respected regardless of the development of flexible font technology'.

Although the rationale for Blissymbolics had at its core a very similar set of principles to Isotype – principles about the improvement of human experience and breaking down linguistic barriers – there is however, a distinct difference in that Neurath had never expected that his system of symbols would be a substitute for text; rather it would be used alongside text and substitute text where possible. Bliss, however, seems to make a claim for his system as a 'language'; a claim, which is continued by the *BCI* as the first sentence of its guidelines:

> *'This document describes the basic structure of the Blissymbolics language, and outlines both the rules necessary to be followed for creating new BCI Authorised Vocabulary, as well as procedures used for adopting that vocabulary.'* [40]

Perhaps it is this claim to language that has been responsible for the mixed reaction to Blissymbolics. Umberto Eco describes the system as 'pasigraphy'[41] and Adrian Frutiger is clear that the claim to see it as a viable language is 'unrealistic'[42]. Blissymbolics is a mixture of different types of signs that require prior learning, both the symbols and the grammatical construction. There are a number of iconic signs that are essentially pictures of things: the house, the chair, the wheel, the tree. These signs are augmented by ideographic signs (signs that represent an idea) and a series of entirely arbitrary signs. These are often mixed together into 'composite bliss characters', such as the sign for food, which is a composite of mouth and earth. The size of the signs also changes their meaning. For example, a full size circle represents the sun whereas a small circle is a mouth. The width, height and weight of each drawn character is also fixed, along with the precise angles used to construct triangles or arrows.

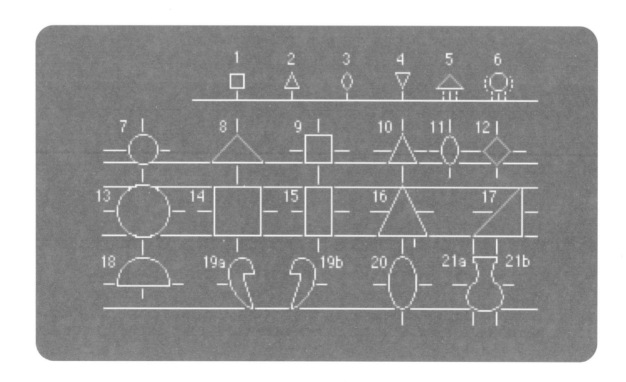

The guidelines issued by the *BCI* read very much like a corporate identity manual and include a flow diagram of the approval process for additions to the language and a committee structure for its policing. All of this makes a very consistent set of symbols, but is very inflexible as a language. Despite the claim that *Blissymbolics* is a 'Living Language' [43] the rather top down development of the system could be interpreted as an illustration of the politics of an 'official' language from Bourdieu's *Language and Symbolic Power*[44], a language that is imposed rather than one that has grown organically through social and technological change. Even the inclusion of 'slang' terms has to be approved by the *BCI*, rather like the addition of new words to the *Oxford English Dictionary*, and they are marked out with a distinct prefix mark. Despite these misgivings, when viewed as a typographic exercise, it has given rise to a fascinating set of symbols and has an interesting underlying logic. The adaptation of typographic terminology to reflect the natural basis of many of the signs is interesting in itself. The baseline becomes the 'earthline' and the cap height the 'skyline'. The careful organisation of the arrangement of the symbols is admirable and the logic behind much of the symbolism is quite charming. As a set of symbols and ideographic pictures with a distinct use, it is perhaps much easier to appreciate. Henry Dreyfuss allocated a significant section of his 1972 book *Symbol Sourcebook: An Authoritative Guide to International Graphic Symbols*[45] to Bliss and his symbols along with a generous description of the work and its author:

'No book related to symbols would be complete without a bow to C.K. Bliss. In Semantography, a word conceived by his fertile imagination, he has developed a complete system that crosses all language barriers. The lines and curves of his symbols, reminiscent of actual objects and actions, are translatable into all tongues. Mr Bliss is an intrepid pioneer; his words and ideas are proudly included in this book.' [46]

43. **The Fundamental Rules of Blissymbolics:** creating new Blissymbolics characters and vocabulary, 2004

44. **Bourdieu, P.** Language and Symbolic Power, Cambridge: Polity Press, 1991

45. **Dreyfuss, H.** Symbol Sourcebook: An Authoritative Guide to International Graphic Symbols, New York: John Wiley & Sons, 1972

46. ibid.

Above. The Blissymbol for **Cool,** a combination of the symbols for 'slang' on the left and 'ice' on the right.

Pasigraph
A linguistic system of ideas or concepts rather than a representation of the sound of a language. With a pasigraph the emphasis is on having a systematic, philosophical approach where it is not necessary to have any grammatical structure.

Ideograph
An ideograph is a sign that denotes an idea. Animals are often used as ideographs, for example, when a lion is used to denote bravery.

Universal Perception / Adrian Frutiger

The typographer Adrian Frutiger brought us typographic blockbusters such as *Univers* with its huge variety of weights and styles and the eponymous *Frutiger*, one of the most widely used corporate typefaces in the West. His monograph of 1980, *Type, Sign, Symbol* draws a direct connection between his work in typography to his designs for trademarks and then to pictorial signs that stand independent of the commercial world. As a designer for international corporations he was inevitably led to consider international communication issues. For him, the design of letterforms and symbols are '...*a universal means of perception that accompanies mankind everywhere*' [47]. *Type, Sign, Symbol* is reproduced in three languages and is in itself a testimony to his international concerns. His work encompassed the design of pictograms to be displayed alongside the typefaces he had made for his clients. He was also commissioned to investigate the typographic possibilities of *Devanagari*, the official Indian script. The work shows not only a deep understanding of letterforms and type design, but also a respect and care for the cultural context he was working with at any particular time. Frutiger's fascination with language and writing wasn't restricted to type design and logotypes for clients. He was clearly interested in the meeting ground between the notation of language and drawing.

47. **Frutiger, A.** Type, Sign, Symbol, Zurich: ABC Verlag, 1980

48. ibid.

'The logotype remains tied to a mainly practical purpose, narrowly defined in meaning, yet in may ways it obtains its life from free drawing. Where then, are the bridges from a logo to a symbol? Where does it free itself as an independent statement of mind.' [48]

Frutiger's approach to pictorial script is fundamentally 'symbolic'. In other words these are signs that have to be learned, unlike the Isotype signs that are a mix of 'symbolic' and 'iconic' signs. Frutiger's symbols do not look like the things they represent. Many of Frutiger's symbols are abstract notions based around creation in some way, or 'Life, Love and Death'. They include symbols for things like *Passion*, *Community* and *Peace*. Frutiger makes full use of Saussure's idea of 'value', which we discussed earlier. The meaning of each sign comes not from the form of the sign, but from the other signs around it and its relationship to them. The signs for *Passion*, *Intimacy* and *Tenderness*, for example, have a distinct similarity in that they all use two elements in their composition, and their meaning comes from the changes in juxtaposition and scale of these elements. Once the reader has the basic code (that these shapes are figurative), then the images are relatively easy to interpret from their composition. Similarly the signs for *Blood*, *Wound* and *Combat* have a direct relationship. However, the underlying code in this case is more difficult to read. It is not figurative and so this sequence relies on the reader learning the initial sign for blood and interpreting the metaphorical changes in the other symbols. Frutiger uses metaphor in his geometry to great effect. The softness and roundness of the symbols relating to life is interrupted by the sharp edges in his symbol for *Wound* and exaggerated in the dynamic symbol for *Combat*.

1.

2.

3.

4.

5.

6.

Left. **Adrian Frutiger,
The Life Cycle,** paper
cut-out symbols, 1962.
1. Blood / **2.** Wound /
3. Combat / **4.** Passion /
5. Intimacy / **6.** Tenderness.

1.

2.

3.

Above. **Adrian Frutiger, Genesis,** woodcut symbols, 1962.
1. Let there be a firmament in the midst of the water and let it separate the waters!
2. Let the earth bring forth living creatures according to their kinds: cattle and creeping things and beasts of the earth!
3. The earth brought forth vegetation.

Overleaf. **Adrian Frutiger, Partages,** woodcut symbols, 1962. Unlike the **Genesis** series that begins with text, this series begins with form itself. The pure geometric circle is subdivided to create disquiet and finally the series returns to harmony. In this series the grain of the wood was carefully chosen to reflect the mood of the symbol, from the harsh grain of the fir tree to the much finer grain of beech.

Frutiger chose the story of *Genesis* to explore the relationship between light and dark in a series of woodcuts made in 1962. Appropriately, it is this first section of the Christian bible that introduces language as a political instrument with the tale of the *Tower of Babel*. The *Genesis* woodcuts follow closely the story from the first book of Moses yet are still easily understandable without the text.

> *'Frutiger must have been aware that the Book of Genesis, although one of the world's most translated texts, still does not exist in all languages. With his signs, comprehensible beyond all individual languages and cultures, he marks and oversteps the boundaries of written language as a means of communication. Thus he succeeds in creating a system of writing independent of language, in fact a universal writing system.'* [49]

49. **Schenkel, R.** in **Frutiger, A.** Forms and Counterforms, Zurich: Syndor Press, 1998

50. **Besset, M.** in **Frutiger, A.** Type, Sign, Symbol, Zurich: ABC Verlag, 1980

In making these woodcuts, Frutiger was influenced by Japanese wood carving techniques where it is the invasion of light into a dark surface that structures the images. For a designer so experienced in designing the rhythm of light and dark, the black of letters against a page, *Genesis* provided the perfect vehicle for experimentation. *Genesis* is a story rich in drama and rhythm, where the very presence of light gives rise to life itself.

> *'The relation between the event itself and the sign which illustrates it is so close that concepts like abstraction, representation or symbol lose their meaning. Genesis is not represented by, it really is the story of light.'* [50]

Immediately after *Genesis*, Frutiger made another set of woodcuts, entitled *Partages*. This was a series of 26 woodcuts published as a limited edition by the same publisher as *Genesis*. This project is perhaps his most complete pictorial script. *Partages* has no accompanying text to help the reader fix the meanings precisely yet one can still read them as narrative. Whereas *Genesis* starts with a black square representing the darkness and the void before creation, *Partages* begins with the circular form. Frutiger creates a series of beautifully balanced symbolic marks that sit quite comfortably in a paradigm with some of the most respected graphic artists of the 20th century, like Miro, Klee and Picasso.
In linguistic terms, the symbols fulfil Saussure's need for the signs to be similar enough to be compared, yet distinct from each other so they can be exchanged. Each symbol has an economy of form that is testament to years of experience in type design.

Frutiger also developed a series of sequential drawings that mirror very closely the way that images are sequenced for film or television. The symbols that convey 'birth' are a series of narrative changes that resemble the time-lapse film of a plant growing and flowering or the lifespan of an embryo. This televisual reference material also seems to affect the nature of the sign itself, as well as its organisation. The signs are more iconic, they look more like the things they represent, and their scale changes to describe the incremental changes in growth one would see through the lens. Given the subject matter of Frutiger's symbols, it would be easy to dismiss this work as 'romantic' or 'spiritual'. In *The Story of Writing*, Andrew Robinson[51] contributes contemporary attempts at protowriting to a fascination with the mystical nature of Eastern culture. It seems that Frutiger is conscious of this type of interpretation:

51. **Robinson, A.** The Story of Writing, London: Thames & Hudson, 1995

52. **Besset, M** in **Frutiger, A.** Type, Sign, Symbol, Zurich: ABC Verlag, 1980

53. **Schneebeli, H.R.** in **Frutiger, A.** Type, Sign, Symbol, Zurich: ABC Verlag, 1980

'The neoromanticism of the sign is foreign to Frutiger, who endeavours to attain the "Urform" (basic form) in quite different ways. For him, original purity is synonymous with universality of form.' [52]

It is technology and its relationship to human concerns that is central to Frutiger and his work. The introduction to *Type, Sign, Symbol* recognises the multiplicity of ways we receive information and points out that it is the aim of the book to achieve an '…overall view within this multitude of possibilities…'. Adrian Frutiger has a long and distinguished career in type design that has as its primary concern the legibility of language. Central to this is the philanthropy of improving communication and putting people first.

'When at the beginning of his personal development, Adrian Frutiger engraved the main European typefaces in wood, he gained a basic knowledge of what is optically acceptable to man. That which the human eye can accept, which is conformable to it, is his first concern, above all a human concern. This is an obligation which cannot be overemphasised in a period when there is a frequent tendency to subordinate man to technical progress.' [53]

Above. **Adrian Frutiger.**
Developmental drawings
depicting growth and birth
referenced from the natural
world.

A New Typography

Day-Glo Constructivism

1. **Saville, P.** Designed by Peter Saville, London: Frieze, 2003

2. **Blackwell, L.** 20th Century Type, London: Laurence King, 2000

The Punk movement of the late 1970s left a legacy of DIY typography that became the basis for a new generation of graphic designers working with type. In the UK the typographic pioneers were the designers working with style magazines and music, where the quick turnaround of essentially ephemeral culture allowed them a license to be playful. The output from the best known of these designers – Neville Brody, Malcolm Garrett, Peter Saville and Vaughan Oliver (V23) – is well documented and these designers were representative of a much larger community of designers who were beginning to generate their own typefaces, as they searched for a typographic signature that expressed the mood of the time. It was a conscious decision for these designers to distance themselves from the mainstream of graphic design. As with the Punk movement, many of the cultural reference points these designers drew on were political ones. Together with Dada and Pop, Russian Constructivism and Futurism were assimilated into contemporary typography with a 'post-modern' attitude that Peter Saville later dubbed 'Day-Glo Constructivism'[1]. For art students in the late 1970s, typography was taught as a traditional craft discipline through letterpress and occasionally phototypesetting. Lewis Blackwell[2] points out that the arrival of new technologies in the 1980s took some time to affect the way typography was treated in art schools. He describes how teaching practice was 'falling a generation behind what was happening around new technology'. With one or two exceptions, most art schools struggled to embrace the new technology. This was partly an economic difficulty, but also a cultural and conceptual one for staff teams who were grounded in traditional techniques. Arguably there were positive outcomes to this traditional approach as the students were often well grounded in terminology, craft skills and historical perspective.

/ Reprocessing

However, the mood of the 'new wave' period was at odds with these traditional values and a new approach was sought to describe this changing cultural force. Designers often resorted to handmade headline letterforms that were drawn by hand or mechanically photocopied from old typography sourcebooks and found objects. At the heart of the studio was the PMT camera (photomechanical transfer). Photographic technology was employed as a creative tool for reprocessing type matter. Although its principal use was to reduce or enlarge drawings to the required size, all manner of things were placed on the baseboard of the pmt camera. Under- or overexposure was used to add atmospheric qualities to letterforms. Type was copied out of focus or moved during exposures. Old chemicals were sometimes kept to one side as they produced poor transfers with a random range of deep seductive tones.

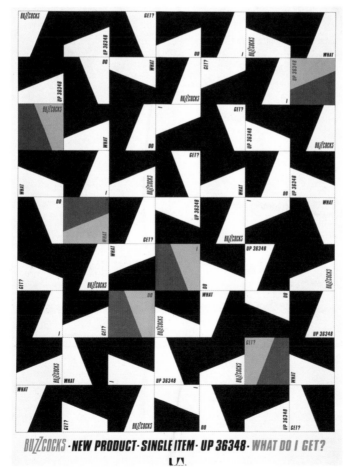

Top. **Malcolm Garrett**, The Correct Use of Soap, Magazine, LP cover 1980.

Bottom. **Malcolm Garrett**, What Do I Get?, Buzzcocks, Poster 1978.

Above. **V23**, Satellite. A pmt rendering of a 3d sculpture used as part of a corporate identity presentation. The reprocessed typography is used to suggest movement.

Top Right. **Vaughan Oliver**, Clan of Xymox LP, 1985. 12-inch record sleeve where both the background and the typography are made using photographic prints from a PMT camera with old chemicals and incorrect exposures. Doll screenprint by Terry Dowling.

Right. **V23**. Realismo
'Pablo's Eye', 1999. CD
album in a limited edition of
500 individual screenprints.
PMT images screenprinted
on to found maps. Art
direction by Vaughan Oliver,
design by Vaughan Oliver,
Chris Bigg and Tim Vary.

For text the typesetting was specified to a bureau either as a typewritten text with handwritten instructions or, where there were only small texts, designers might dictate the text and specify the font, size, leading, alignment etc. over the telephone. Having a good relationship with the typesetter was hugely important. When the means of production was eventually given over to designers in the late 1980s, many realised for the first time just how much skill and care had gone into their scrawled instructions. A good typesetter would take care with line breaks and kerning as a matter of course. They would know each designer's preference for spacing. They understood the latest typographic affectation and could interpret the designer's description.

As with the pmt camera, the practice of manipulating the technology to create something unfamiliar was commonplace. To be able to 'see' the technology in the type was consistent with an industrial aesthetic prevalent at the time. The medium was the message in typography just as it was in music. The manipulation of machines to create unexpected new sounds was directly reflected in the representations of this music. The type size and the body size were specified separately to mechanically stretch the letterforms in every direction; letterforms were treated as a series of small pictures to be manipulated. Legibility was an issue to be played with rather than a set of rules to be followed.

3. **Triggs, T.** The Typographic Experiment: Radical Innovation in Contemporary Type Design, London: Thames & Hudson, 2003

Style magazines like *The Face, New Sounds New Styles* and *i-D* in the UK were arguably more concerned with what Lewis Blackwell describes as 'Viewability' rather than legibility. Teal Triggs[3] describes how the issues of legibility and readability were brought to the foreground as designers used the advances in computer technology for self-expression and experimentation in a backlash against the objective logic of Swiss modernism. Typographers were generating an emotive visual dialect that spoke to distinct audiences in a way that defined membership of the group.

Right. Low-tech typographic experiments from author's sketchbooks.
Pulling type through a fax machine and moving type on a photocopier, 1985.

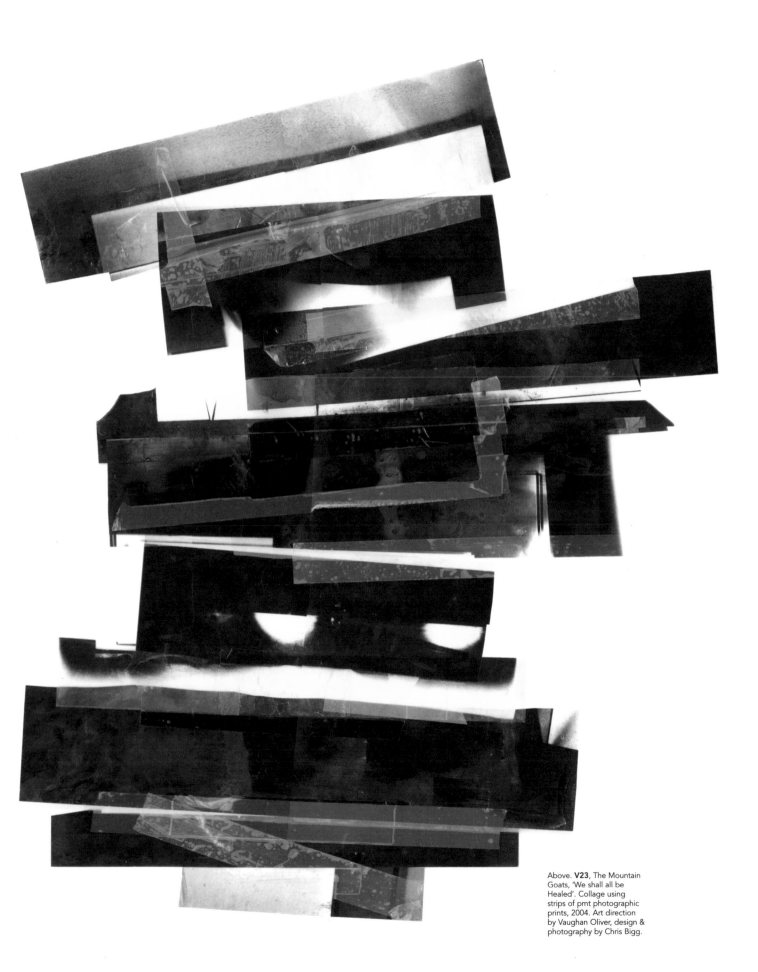

Above. **V23**, The Mountain
Goats, 'We shall all be
Healed'. Collage using
strips of pmt photographic
prints, 2004. Art direction
by Vaughan Oliver, design &
photography by Chris Bigg.

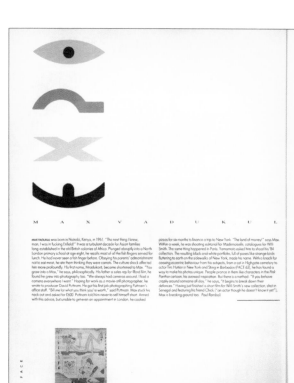

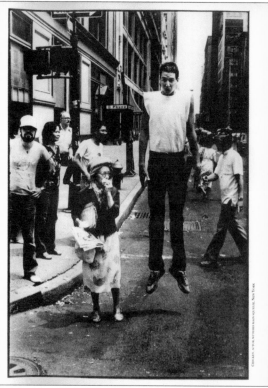

The Face @ 4th Floor, 5/11 Mortimer Street, London W1, England

Publisher/Editor: **Nick Logan**
Assistant Editor: **Paul Rambali**
Designer: **Neville Brody**

Features: **Paul Rambali**
Intro/Features assistants: **Lesley White**
Accounts/subs: **Julie Logan**
Design assistant: **Ben Murphy**
New York Editor: **James Truman** (212) 989-9578
Ad Manager: **Rod Sopp** 01-580 8760

THE FACE 7

The Face @ 4th Floor, 5/11 Mortimer Street, London W1, England

Publisher/Editor: **Nick Logan**
Assistant Editor: **Paul Rambali**
Designer: **Neville Brody**

Features: **Paul Rambali**
Intro/Features assistants: **Lesley White**
Accounts/subs: **Julie Logan**
Design assistants: **Ben Murphy, Valerie Hawthorn**
New York Editor: **James Truman** (212) 989-4578
Ad Manager: **Rod Sopp** 01-580 8760

40/41

Clothes by Crolla,
photography by Sheila Rock

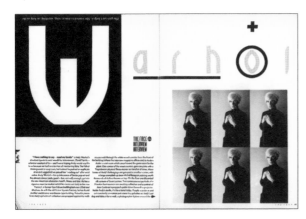

Opposite (Top).
Neville Brody, cover designs for The Face magazine. A combination of typesetting and hand-drawn type in bold, asymmetric layouts. The Face no. 34, Feb 1983 and no. 50, June 1984.

Opposite (Bottom).
Neville Brody, 'Expo'. Spread from The Face magazine no. 69, Jan 1986. Hand-drawn abstracted letterforms for the feature header.

This Page.
Neville Brody. A range of hand-drawn abstractions of letterforms for 'contents' section, 'film' section and for The Face interview with Andy Warhol, 1984–85. The 'contents' section was used to push the viewer beyond accepted norms of legibility to a position of readability based on an unfolding abstraction from month to month.

New Primitives

Below left. **David Crow, Trouble No.1**, 1986. Screenprinted poster and initial sketches for the poster made using a Mac classic. The headline type is output from a linotronic setter and is specified on a body size smaller than the point size to achieve a 'stretch' from the technology. The Trouble 'logo' was drawn using a 'Robocad' joystick system, intended for engineering drawing.

Below Right. **David Crow, Trouble Poster**, 1990. Full colour poster created by taping a number of elements to a colour photocopier and quickly swapping the elements between each pass (Cyan, Yellow, Magenta, Black) of the scanner head.

Although the Macintosh classic was released in 1984, it took some time to arrive in earnest in the UK and many studios and art schools still worked without a computer well into the 1990s. Nevertheless its impact on a conceptual basis, if not always on a practical basis, was immediate. For the first time, graphic designers had at their disposal a complete environment for design, production and output. Although it was crude, it represented an empowerment that was entirely new.

The new technology brought about what Lewis Blackwell describes as a 'new perception' of the subject. The 'Mac' had arrived, bundled with a very small number of fonts as part of the operating system of the machine. Initially these fonts were designed to be viewed rather than printed and generated very coarse renditions of letterforms when output. This crudeness did not deter designers who were fundamentally excited by the concept of digital production and the coarse bitmaps became part of a new aesthetic. For example, the font 'Moonbase Alpha', designed by Cornel Windlin, was a recreation of an accidental pixelated printout of Akzidenz Grotesk set at 4 point. ATM (Adobe Type Manager) had not been installed on the Mac and the Stylewriter printed what was on the screen. The fascination with the idea of using computers to generate graphic design extended to almost any new media. It was a period of genuine discovery where many designers were prepared to use whatever new tools were made available with a naive yet passionate enthusiasm for a new age. The new generation of colour copiers were turned into printmaking machines, black and white copiers came with a photographic zoom capability, cad software was used to draw type and the introduction of the fax machine to the office gave designers a new toy to play with.

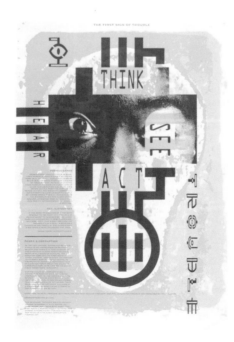

This page. **Malcolm Garrett**, Boy George, Sold, 1987. Front and back of LP sleeve. An eclectic overlay of fashion photography, international price tags and found imagery, Malcolm Garrett's work appeared to anticipate the effects that the arrival of the world wide web would have on visual language – a visual overload where everything is at our finger-tips, freely mixed cultural references and an online consumer boom. The title 'Sold' is a reworking of the Sex Pistols's logo, which is itself a reworking of found typography. The low-tech quality of the source material is celebrated and draws our attention to its mass manufacture. Photography by Paul Gobel, Johnny Rosza, Bill Ling.

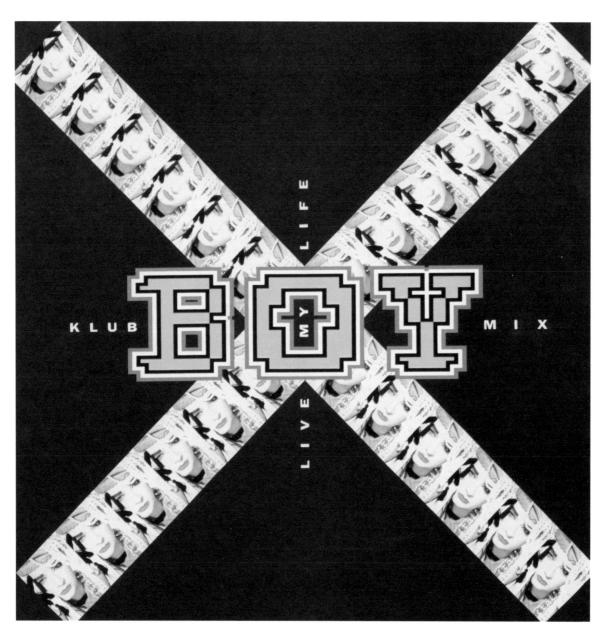

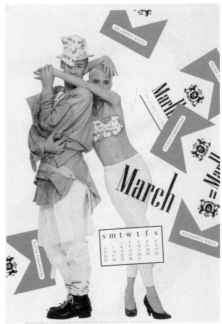

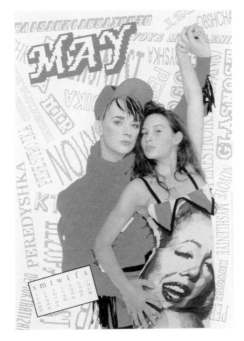

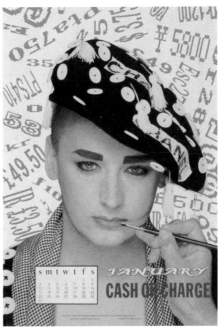

Opposite Top. **Malcolm Garrett**, Boy George, Live My Life, 1987. A celebration of the bitmap aesthetic. The low-tech bitmap is decorated with a sophisticated colour palette and multiple outlines more usually associated with the scripts from luxury packaging. Photography by Mark Lebon.

Opposite Bottom. **Malcolm Garrett**, Boy George, To Be Reborn, 1987. Single sleeve that features an early use of the typography as a bitmap script. The back of the sleeve also has an empty picture box that gives the entire package the feel of the screen where it was constructed.

Above. **Malcolm Garrett**, Boy George, Sold, 1987. 'Retrievalism' visualised as pages from a promotional calendar that feature a number of references to existing packaging and logotypes.

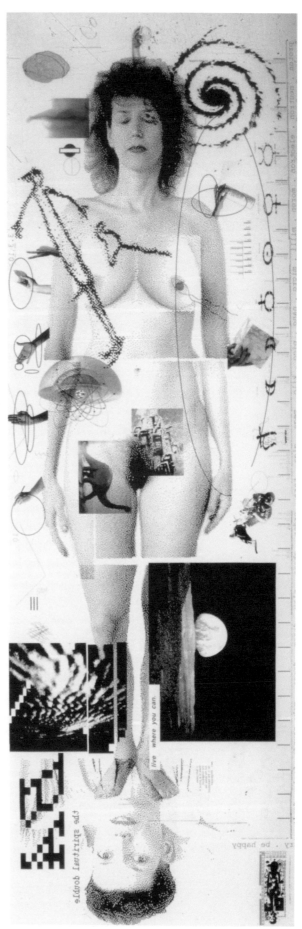

Right. **April Greiman**, Poster
for Design Quarterly no. 133,
1986.

Above. **Ian Mitchell**, Poster
for Baseface font published
by Beaufonts.com. Bitmap
font designed to cope with
the technical limitations of
reproducing type at a small
size on a screen. The 1990s
brought a boom in screen-
based graphic design that
fed a revival of the primitive
bitmap aesthetic established
in the 1980s.

New Primitives / Neo-Modernism

Below. A range of fonts inspired by a technological aesthetic.
Zwart Vet by **Max Kisman**, 1987 & 1990 /
Oakland 10 by **Zuzana Licko**, 1985 /
Moonbase Alpha by **Cornel Windlin**, designed for Fuse no. 3, 1991.

Ellen Lupton and Abbott Miller point out how many of the first Mac-generated typefaces follow an approach to typography from some 60 years earlier. The restricted set of geometric elements of *Variex* (Zuzana Licko, 1988) or *Zwart Vet* (Max Kisman, 1987) owe much to the geometric fonts of Albert Bayer, Theo van Doesburg and Herbert Bayer. The pioneer spirit of the designers from the 1920s was taken as a reference point for the new typographic pioneers. Lupton and Miller point out that although they share a common reference point in technology, in essence the new fonts did little to push the boundaries of what had already been seen in the historical avant-garde.

Despite this initial aesthetic revivalism, it was nevertheless a period of technical innovation where type designers along with software designers quickly refined the resolution and management of digital type. Type designers such as Matthew Carter, Charles Bigelow and Chris Holmes set about designing text faces for the new technology that took account of the resolution problems and the coarse output. For many young designers and students this was largely a hidden activity. Perhaps unsurprisingly the excitement was centred around the immediacy of the new environment and a refreshing sense of experiment that it brought. It was an important time as designers were beginning to form how graphic design would look in a digitally enabled world. One of the first to seize the opportunity to explore the new software was the American designer April Greiman, who published her much-publicised life-size self-portrait in *Design Quarterly* in 1986 (see also page 157). The reverse of this huge and complex poster was credited with all the software used and this celebration of technology is completed with the note that it contains 289,322 bytes of information.

Light the Blue Touch Paper and Stand Well Back

4. **Blackwell, L.** 20th Century Type, London: Laurence King, 2000

FFBlur

Above. FFBlur designed by **Neville Brody** (1991). The PMT camera was used to reduce and enlarge type and drawings so they could be pasted down for printers. Brody was deliberately copying artwork out of focus under the camera to create expressive typography. When typographic software enabled designers to create their own fonts, Blur was one of the first Brody made. Despite its experimental and vernacular origin, Blur is still popular today and is regularly used in 'mainstream' graphic design.

By the early 1990s the new technology was already being used to design fonts and format them for immediate use by others. The proliferation of type design during this period was unprecedented, as it became the focus of a generation of graphic designers. Thousands of typefaces were being made, distributed, swapped, sampled and sold. As a result the period gave birth to independent font companies, some of which have now become firmly established as type design houses.

The larger type design companies quickly set about digitising their libraries and offered thousands of fonts in what Blackwell[4] describes as 'pile 'em high, sell 'em cheap tendencies'. In the USA the *Émigré* type library was growing and by 1997 it boasted around 200 faces. Lewis Blackwell points out how *Émigré* illustrated that type 'brands' could be launched using the new technology. *Émigré* and very soon afterwards, *FontShop International* (FSI) in Europe, established an approach to type design that was closely related to a philosophical or ethical standpoint about typography and design. The designs were still experimental in form and many showed an entirely new conceptual framework for typography. This gave their brands a cultural capital that could not be matched by the large companies. It was in many ways a model for establishing new business, which had been introduced in the music industry during the Punk and New Wave era where so many of the designers had worked or were still working. The means of production had become freely available at low cost, which created a strategy of releasing a product that was challenging and culturally interesting in the hope that an occasional hit would finance the next set of releases. Distribution networks were used to get a product into various territories so that operating costs were kept as low as possible.

Erik and Joan Spiekermann – who were based in Berlin – and Neville Brody in London, founded *FSI*. Both Erik and Neville were already well known and their reputation drew in new designers who shared their vision of creating fonts 'by designers, for designers'. A well-organised distribution system enabled *FSI* to grow at a faster rate than *Émigré* had done and by the end of 1997 *FSI* had a library of around one thousand typefaces.

TYPE CULTURE.
TYPE FACT.
TYPE IS TRUST.
TYPE IS FAITH.
TYPE IS ENTERTAINMENT.
...

IS
IS
IS
IS

TYPE IS
TYPE IS
TYPE IS FA
TYPE IS ENTE
TYPE IS
TYPE
TYPE

Left. Quotation from opening
address by Neville Brody at
the Fuse 98 conference in
San Francisco, USA.
Set in 'Confidential',
'Dynamoe', 'Flightcase' and
'Stamp Gothic' designed by
Just van Rossum, 1991.
The arrival of font authoring
software enabled designers
to take the letters they saw
in the world around them
and convert them into
typefaces. These 'Instant
Types', published by FSI,
are essentially 'pictures' of
letterforms.

LANGUAGE EVOLVES
FROM CULTURE
WHEN WE ATTEMPT
TO DICTATE LANGUAGE
WE DESTROY CULTURE
...

Fuse

Type design became the arena for young designers and students to express themselves, manipulating the software available to produce highly personal autographic marks or create conceptual constructions of language in a manner that owed much to the increased interest in post-modern theory in art schools.

For many young designers and students it was *Fuse* magazine, founded by Neville Brody and Jon Wozencroft, published through *FSI* that caught their imagination. *Fuse* grew from the same political idealism that gave us the Punk movement, an excitement that we could take control of our own language by having access to the means of its mechanical production. It was a direct result of the possibilities of the new font authoring software combined with the dismay among many designers of the consumer-led 1980s in the UK. Each *Fuse* release gave a group of four designers the opportunity to publish an experimental font free from the customary restrictions and conventions of a commercial brief. Each issue was themed (e.g. invention, religion, cities) and accompanied by an essay that put the theme in critical and theoretical context.

By this time the graphic design courses in art schools up and down the country were beginning to adopt a new set of critical reference points borrowed from linguistics and semiotics. The texts of the 'structuralists' gave the discipline an academic rigour after a period where mainstream graphic design had lost the respect of the public through meaningless surface makeovers. 'Structuralism' was the name given to an intellectual current based on Saussure's call for a science of signs. A new agenda was being formed for typography by re-examining the relationships at the heart of language: the relationships described by Saussure as the signifier and the signified, the fundamental building blocks of language. Designers were using the new software to create a new set of relationships with the keyboard.

Right. Quotation from opening address by Neville Brody at the Fuse 98 conference in San Francisco, USA. Set in 'Stealth', designed by **Malcolm Garrett** for Fuse no.1, 1991 and 'Moonbase Alpha', designed by **Cornel Windlin** for Fuse no. 3, 1991.

in western society, **TYPOGRAPHIC** creation and design had been largely placed in the hands of a few highly-trained practitioners, in a monastic fashion. this closed-shop practice fuelled a self-referential elitism at the heart of the control mech-anism governing our typographic systems and core elements. this elitism was challenged by the advent of the pc, when tools for designing fonts became readily available, and led to a democratisation of the typographic **PROCESS**

5. **Blackwell, L.** 20th Century Type, London: Laurence King, 2000

The notion of 'random variation' was introduced in the form of *Beowolf*, designed by Dutch designers Erik van Blokland and Just van Rossum. Beowolf, published in 1989 by *FSI*, was a landmark in digital type design as it was arguably the first example of designers manipulating the technology at the level of coding and marks the birth of the so-called 'intelligent fonts'. This introduced a random change in the letterform based on the user's actions that removed the hitherto unchallenged certainty in the relationship between what you type and what you get as a result. These relationships were further developed by a number of image-based fonts where, for instance, typing the letter 'A' might produce an entirely different mark from an entirely different paradigm than the one that convention led us to expect. Lewis Blackwell acknowledged this in his critical retrospective *20th Century Type*, published at the end of the 1990s:

> *'The various experimental, often unreadable symbol-based fonts developed by the Fuse project also explore the dynamic of the typographic engine in a way that steps beyond the expectations and strictures of our conventional alphabets.'*[5]

Neville Brody anticipated this new approach to typography with his declaration that typography as we had known it previously was over. The onslaught of the digital age was about to challenge conventions and traditions that were centuries old.

Including ten fonts by Neville Brody, David Carson, John Critchley, Tobias Frere-Jones, Jon Wozencroft, Cornel Windlin **Freeform FUSE 10**

FontShop Austria (0222) 523 29 46 Fax (0222) 523 2947-22 FontShop Benelux (09) 220 65 98 (09) 220 67 25 (09) 221 32 08 Fax (09) 220 34 45 FontShop Canada MAC: 1-800-36-FONTS PC: 1-800-46-FONTS Fax 416-593-4318 FontShop France (1) 43 06 92 30 Fax (1) 43 06 54 85 FontShop Germany (030) 69 58 95 (030) 692 88 65 FontShop Switzerland (044) 3 26 26 Fax (044) 3 26 27 FontWorks UK (071) 490 5390 (071) 490 2002 Fax (071) 490 5391 FontShop US MAC: 1-800-36-FONTS PC: 1-800-46-FONTS Fax 416-593-4318

Fuse / Typing Pictures

Art students quickly adopted this shift away from the conventional use of the alphabet. The latest release of *Fuse* was an eagerly awaited event and the *Fuse* conferences in the early 1990s became a Mecca for aspiring students of typography. This move is consistent with Leonard Shlain's proposal[6] that we have seen a return to image-based communication in recent years (see page 142).

> '*To perceive things such as trees and buildings through images delivered to the eye, the brain uses wholeness, simultaneity, and synthesis. To ferret out the meaning of alphabetic writing, the brain relies instead on sequence, analysis and abstraction.*'[7]

The critic Michael Rock offers the view that despite *Fuse*'s desire to provide a platform for experiment, many of the contributions encouraged repetition. The majority of the fonts followed the accepted convention of the Roman alphabet and varied only in the way that the alphabet was 'spoken'[8]. It was what Lewis Blackwell described as 'the unreadable symbol fonts' that provided the arena for something that could be considered truly experimental. This was a genuine attempt to bring content to typography – a media more readily described as a neutral carrier of content. The intention was to highlight the political nature of language and reflect on its underlying structures with themes like 'Code', 'Propaganda' and '(Dis)information'. *Fuse* described this development as 'Freeform' typography, a term more readily used to describe music or painting. If typography is to be considered experimental, then it should be a challenge to convention in some way. It might challenge the convention that there is a predetermined number of units used to arrange language, or it seeks to create a language or dialect of its own. As *Fuse* moved away from the Roman alphabet it began to explore the relationship between the user and the keyboard. What you saw was no longer what you got. Could language cluster itself around a set of signifiers that did not rely on conventional structures and attitudes? *Fuse* began to challenge the political boundaries that have been so entwined with language and the alphabet for many centuries.

6. **Shlain, L.** The Alphabet Versus the Goddess: The Conflict Between Word and Image, New York: Penguin / Arkana, 1998

7. ibid.

8. **Rock, M.** 'Beyond Typography', Eye Magazine, No. 15, Vol.4, 1994

Opposite. **Neville Brody, Fuse 10 – Freeform** Poster, 1994.

Typographic treatments
made using Mutoid font by
John Critchley for Fuse 10,
1994 and Surveillance font
designed by **Florian Heiss**
for Fuse 17, 1997.

Above. Student fonts from
Dept. of Graphic Arts at
Liverpool School of Art &
Design.
Left. 'Georgian Liverpool'
by **Dominic Witter**.
Right. 'Widdecombe' by
Yuko.
Bottom.'Blind' by
Raj Jawinder.

Opposite. 'Widdecombe'
by **Yuko** and 'Blind' by
Raj Jawinder.

L

v

L

b

'Peecol' by **Eboy**,1998
By typing between upper
and lower case characters,
the user can create their
own illustrations.
Peecol is available as a
range including Basic, Ebot,
Kicker, Play, Talk and Test.
Each 'weight' of Peecol is
supplied with a second
colour infill version to
enable multicoloured
characters. This draws on a
tradition established by
letterpress block printers
from the previous century
who frequently used second
colour blocks to infill or
shade letterforms.

9. **Triggs, T.** The Typographic Experiment: Radical Innovation in Contemporary Type Design, London: Thames & Hudson, 2003

10. **Poynor, R.** No More Rules: Graphic Design and Postmodernism, London: Laurence King, 2003

11. **Wozencroft, J.** The Graphic Language of Neville Brody, London: Thames & Hudson, 1988

Above. 'Creation 6' font by **David Crow** font published in Fuse no. 8, 1993. A selection of characters to describe a creation myth. From top; in the beginning / the stars / the magical act / middle-aged man (in ill health) / the festival.

The presence of the camera could also be felt in some of the contributions to *Fuse*. Paul Elliman provided a number of fonts that are fundamentally photographic. In *Photo-booth alphabet (Fuse 5: Virtual 1992)*, a series of head and shoulders portraits describe the letterforms. *Photo-booth* occupies a position between the alphabet and illustration and draws on a tradition that can be traced back to the decorative letterforms of ancient manuscripts, like the *Book of Kells*, where the letterforms combine with figurative shapes. In *Bits (Fuse 15: Cities 1995)* Elliman offers the user photographic fragments of the city presented as a series of silhouettes that rely on the viewer having prior knowledge of the alphabet to locate these silhouettes as letterforms. Teal Triggs[9] points out that these letterforms are part of a paradigm of typography and writing, but also part of a paradigm of industrial fragmentation alongside Tony Cragg's sculptures and the 'letter' photographs of Walker Evans and Lee Friedlander. Elliman has an undeniable fascination with the ongoing production of language. In *Bits* Paul Elliman explores the ability of western society to 'recuperate' material from a variety of sources into contemporary visual language. For Elliman, the aim of the project is to shift the material from one paradigm of industrial production into another – the digitised world of mechanical typography. The fact that the source material has been through a process of becoming 'worthless' is precisely what enables Elliman to reinvent it for a new purpose so successfully. Only when the objects have lost all cultural meaning is the artist able to change their meaning unshackled by previous association. *Fuse* also acknowledged the past and its typographic heritage by addressing themes like 'Religion' *(Fuse 8: Religion 1994)* – an opportunity to reflect on the role of the church in the development of literacy and how it was used to its advantage. This issue included historic references and new symbols to build contemporary creation myths. *Fuse* also took a speculative look at the future with 'Genetics' *(Fuse 16: Genetics 1996)*, an invitation to consider the genetic growth of typography and the possible direction of its future development. *Fuse* magazine attracted a good deal of criticism. Some of the criticism was based around the supposed 'romanticism' of its intentions or the perception of *Fuse* as publishing for a 'visual elite at the expense of a broader public discourse'[10]. Other critics saw the fonts as having no immediate practical use in a much more prosaic design industry servicing a client and a target audience that simply would not understand the codes nor take the risks. Despite all this, the project was hugely influential in introducing the critical debates around language to design students all over the world and sharpened our sense of the politics of both language and technology. This quotation from one of its creators, Jon Wozencroft, three years prior to *Fuse 1*, illustrates the motivation:

'A parallel between the industrial revolution and the technological revolution is that both are geared to social control. As information becomes based on the language of airports and computer terminals, the role of design has never been more crucial, nor more widely abused.'[11]

Above. 'Sugo' by **Paul Elliman** is a series of logos for the Italian magazine, 2006. Elliman uses his 'Bits' alphabet to generate an identity for a magazine that takes the original found material back into mainstream visual culture.

Overleaf. 'Bits' alphabet by **Paul Elliman.** Examples of the original source material for the project, alongside part of the collection as mechanically reduced silhouette letterforms.

Above. 'Megafamily' font
by **David Crow**, Fuse 16:
Genetics. 'Megafamily' is a
game for two players in
QuarkXpress. By typing
between upper and lower-
case characters the players
create a thumbnail sketch of
imaginary offspring.
Right. 'Cicopaco' font by
Alexei Tylevich, Fuse 16:
Genetics.

The Printing Press

For centuries, scribes in monasteries reproduced books by hand at a very slow pace. These theological texts were very expensive and were made exclusively for the clergy and nobility. Towards the end of the 12th century, the art of paper-making finally arrived in Europe and was followed by the appearance of a new type of professional scribe. As a result the monopoly of the Church over education began to weaken and the content of books was extended during the 13th century to include philosophy, mathematics and astronomy. However, books remained very much the property of an elite. This began to change dramatically with the introduction of mechanical printing and moveable type. Johannes Gutenberg of Mainz was the first to mechanise printing around 1447. At the same time, his colleague, Peter Schoeffer, found a way of casting letters in a lead alloy.

Although the Chinese had been using moveable type since the 11th century and had been making paper for many centuries prior to that, it was the arrival of these technologies in Europe that precipitated wholesale change. From the 1460s onward the use of the Mainz printing press spread throughout Europe and by the start of the 16th century printing houses appeared complete with engravers, type-casters and compositors. In a search for aesthetic perfection, the proportions of letters were mapped against the human form and in France, Claude Garamond developed what are still considered to be some of the most elegantly proportioned typefaces available.

The early 1700s saw the creation of a whole new set of faces to capture the spirit of the time and marks a distinct move away from handwriting. William Caslon developed types that were used for the reproduction of the American Declaration of Independence in 1776, John Baskerville was creating new types that were much copied, and in Italy Giambattista Bodoni created a new type that was subsequently bought by the Pope and spread throughout Europe.

The printing press itself underwent significant technical improvements. A cylinder system was introduced to replace the flat plate accompanied by automatic inking, resulting in an increase in production from 250 sheets a day to over 1000 sheets an hour. In 1828, the British inventor Edward Cowper produced a press for *The Times* newspaper that enabled the printing of 8000 sheets per hour and by 1939 *The Times* was printing 40000 copies of the newspaper each hour.

Alphabetic literacy rates soared in the wake of the explosion of publishing and there is no doubting that Gutenberg's invention helped to spread knowledge across Europe and beyond. However, it is impossible to divorce knowledge from power.

Opposite. Composition set in 'Creation 6' font by **David Crow**, published in Fuse no. 8: Religion, 1993. 'Ornamental Rugs' font by **Jonathan Hitchin**, published by Beaufonts.

context

context

Gender and the Alphabet

12. **Shlain, L.** The Alphabet Versus the Goddess: The Conflict Between Word and Image, New York: Penguin / Arkana, 1998

Leonard Shlain's thesis *The Alphabet Versus The Goddess*[12] proposes that whenever a culture elevates the written word, then patriarchy dominates and conversely, when the importance of images dominates the written word then it is feminine values that come to the fore. Shlain himself recognises that at face value, this thesis does not appear to make sense. Surely the women's movement is itself testimony to the spread of knowledge that the alphabet has enabled. However, his study of the origins of writing appears to parallel the demise of women's position within society. In Mediterranean countries, the so-called 'crucible of civilisation', the Goddess was the principle deity. In Egypt it was Isis, in Sumer it was Inanna, in Greece we had Demeter, and in Cyprus Aphrodite was worshipped.

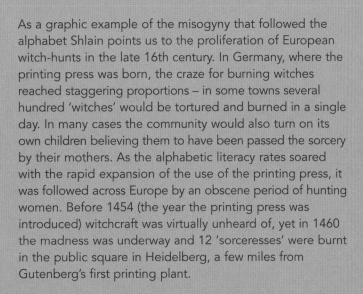

As a graphic example of the misogyny that followed the alphabet Shlain points us to the proliferation of European witch-hunts in the late 16th century. In Germany, where the printing press was born, the craze for burning witches reached staggering proportions – in some towns several hundred 'witches' would be tortured and burned in a single day. In many cases the community would also turn on its own children believing them to have been passed the sorcery by their mothers. As the alphabetic literacy rates soared with the rapid expansion of the use of the printing press, it was followed across Europe by an obscene period of hunting women. Before 1454 (the year the printing press was introduced) witchcraft was virtually unheard of, yet in 1460 the madness was underway and 12 'sorceresses' were burnt in the public square in Heidelberg, a few miles from Gutenberg's first printing plant.

Opposite. Composition featuring 'Restart' font by **Jon Wozencroft**, published in Fuse no. 10, 1994. 'Mayaruler' font by **Jon Randle**, published in Fuse no. 15, 1995. 'Silicon' font by **Jonathan Hitchin**, published by Beaufonts, 1999.

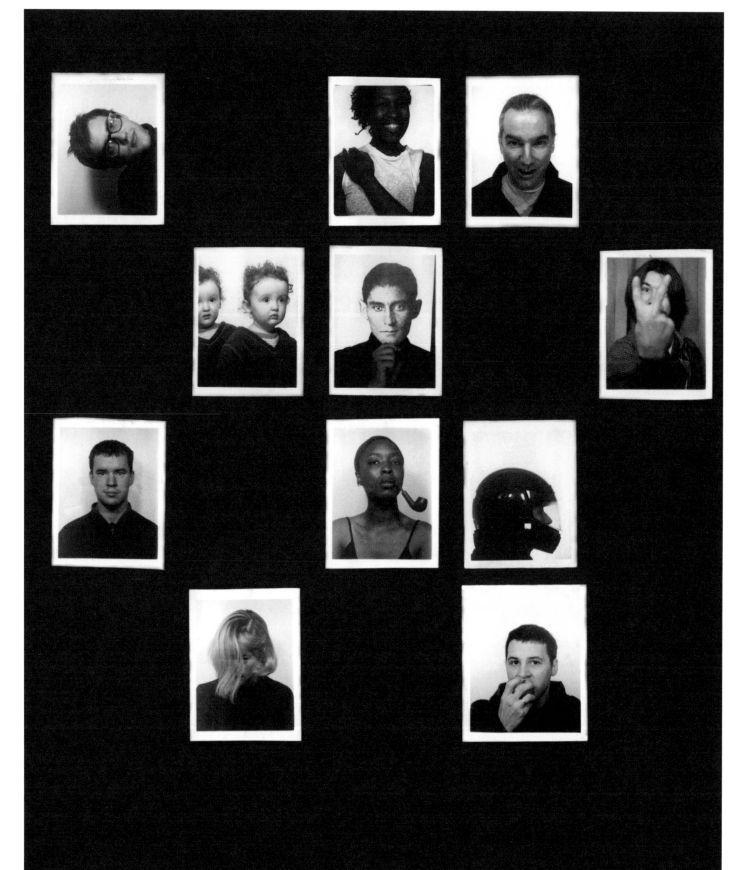

Gender and the Alphabet / cont.

13. **McLuhan, M.** The Medium is the Message, London: Bantam Books/Random House,1967

14. **Shlain, L.** The Alphabet Versus the Goddess: The Conflict Between Word and Image, New York: Penguin / Arkana, 1998

Opposite. 'Photo-booth Alphabet' by **Paul Elliman**. This project predates its inclusion in Fuse (1992) and has been given a new life since as the London International Festival of Theatre (LIFT) has added to the project by extending the contributions during 2006.

Below. 'Pussy Galore' font by **Teal Triggs, Liz McQuiston and Sian Cook, WD+RU**, published in Fuse no. 12, 1995.
The Fuse poster carried a statement from the WD+RU that; *'Women and technology are equal parts of the future and, for women, technology is the vehicle for their liberation.'*

This is not an isolated incident. Shlain's thesis is full of such examples. In the 1470s the printing presses reached Spain and the Inquisition began in the early 1480s. Despite it being a period of prosperity in Spain, the Spanish monarchy threw the country into an eruption of male-dominated aggression as they ruthlessly persecuted all deviations from the Catholic faith. Spain entered a period of Church-sanctioned torture where the 'guilty' were burned in public and their possessions retained by the church. Its exploits overseas were equally horrific. Christopher Columbus was busy destroying the indigenous culture of Northern America and teaching the 'savages' the Latin alphabet so they could read the Christian Bible. This was a prerequisite for converting the natives from their worship of the 'Great Mother' to the Christian 'God'.

Shlain attributes this apparent correlation of male domination and the rise of the alphabet not just to the politics of language and the socio-economic conditions that accompany the introduction of scripts; he points out that each medium is distinctive and has its 'own technology of transmission'. Just as the use of television or photography has its own impact as a medium, the same is true of the use of the alphabet. Whatever the content of a message, we cannot deny that we read the medium at the same time and this affects our reading of the message. This idea was eloquently described by Marshall McLuhan in *The Medium is the Message*[13] and has been extended by Shlain to include the physiological differences of reading the alphabet against reading pictures. His ideas are grounded in the notion that a different part of the brain is used to read the alphabet than the part used for reading pictures. When reading the logical, linear sequences of abstract alphabetic writing we use the left-hand side of the brain. This is the side that is characteristically strongest in the male population. As a contrast, we read images with the right-hand side of the brain, the side that is better suited to reading 'all at once'. This side of the brain favours what Shlain calls 'holistic' reading and is stronger among women.

'To perceive things such as trees and buildings through images delivered to the eye, the brain uses wholeness, simultaneity, and synthesis. To ferret out the meaning of alphabetic writing, the brain relies instead on sequence, analysis and abstraction.'[14]

Saved by Television

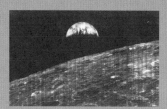

Right. First View of Earth from Moon, 08/23/1966. The world's first view of Earth taken by a spacecraft from the vicinity of the Moon transmitted to Earth by the United States Lunar Orbiter I.

Opposite. The Mushroom cloud seen from an American aircraft. Image reproduced courtesy of the Nagasaki Atomic Bomb Museum.

15. **Shlain, L.** The Alphabet Versus the Goddess: The Conflict Between Word and Image, New York: Penguin / Arkana, 1998

If we fast-forward to the end of the Second World War we find the introduction of the next major cultural force, the television. The cathode ray tube reversed the solitary practice of communication through reading to a group activity in front of the TV. Families were brought together around the box of glowing images. Apparently the EEG brainwave patterns of someone watching TV are so different to those of someone reading that even when the content of the book and the film are the same, the brainwaves remain entirely different. According to Shlain[15], were you to look up from this booklet and begin to watch TV, the left side of your brain would idle and the right side of your brain would switch on. Television has greatly increased the power of images and as a result, alphabetic information has been superseded by other types of symbolic and iconic information as the dominant force in contemporary societies. Shlain singles out two images as being the most influential. The first is the mushroom cloud produced by the explosion of the atomic bomb in Hiroshima – a dramatic resolution to the political difficulties of the time and in Shlain's view, the finale to thousands of years of left-brain dominance. The second image is the picture of Earth, taken from space – a reminder that the planet needs to be looked after rather than conquered. He argues that the image of our planet floating in blue space did much more to shift our consciousness of environmental issues than the miles of text written by the world's writers.

At the same time that we began to see a rise in the importance of the image, we also began to recognise a new condition among school children. The rise in diagnosed cases of dyslexia has gone hand in hand with the rise of the image. Dyslexia is a condition that is explained through the dominance of the right hemisphere of the brain and dyslexic people struggle to varying degrees with the linear left-brain logic of reading text. It is perhaps no surprise that the numbers diagnosed have risen as we have begun to recognise different modes of thought, nor is it surprising that large numbers of dyslexic people find themselves studying art- and design-based subjects where they feel much more comfortable.

The irony that Leonard Shlain's thesis, and this book, is communicated through text is not lost. Of course the written word has been the primary tool in communicating a vast range of important ideas for many years. Its ability to provide precision and detail is uncanny and arguably unrivalled. However, an equilibrium has perhaps begun to appear in the latter half of the 20th century, which may provide part of the explanation for the undeniable pattern among young designers of using text-based software to enable image-based language systems.

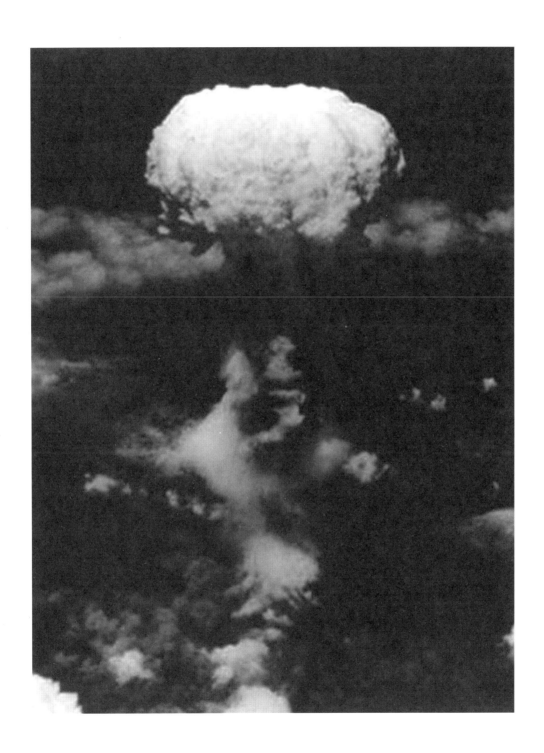

Safety, Speed and Commerce

The Pictogram

1. **Neurath, O.** International Picture Language, London: Kegan Paul, Trench, Trubner & Co., 1936

2. **Frutiger, A.** Type, Sign, Symbol, Zurich: ABC Verlag, 1980

Much of our daily life is assisted and structured through the use of pictograms that function as directions, orders, warnings, prohibitions or instructions. Transport systems and other business-related networks now extend well beyond the boundaries associated with any single spoken language. The sheer volume of human traffic through public spaces means that physical signs have become an unavoidable part of our environment. These days we are much less likely to 'ask' for help, particularly in exterior spaces, and search instead for a pictogram to help us get to where we want to go. Today's pictograms are the contemporary evolution of the *Isotype*[1] signs designed by Otto Neurath and his colleagues in the 1920s and '30s. Neurath may not have intended his work to be used in this way, but his work established a set of guiding principles that are still the basis of today's industrial signs.

The design of pictograms has a rational theoretical approach that underpins their form. The shapes of signal panels are chosen for their ability to make a strong visual impression. Form follows function. The designer Adrian Frutiger, who has created sign systems for a range of public spaces, describes how:

> '*Circular panels, which bear some resemblance to the raised open hand, are the most clearly visible against their background*' whereas '*Square or oblong shapes tend to be submerged into the general townscape*' and '*The circles and the oblique line provides a much stronger contrast to the urban environment.*'[2]

Colour coding also has an associated set of principles based on the quantity of particular colours that can be seen in the natural environment. Red, for example, is the most widely used warning colour as red is present in 'dots' whereas other colours appear in blocks. These principles vary slightly from subject to subject and the coding is contained within paradigms of different activities. The significance of red and green vary conceptually from traffic management to electric workshops.

Opposite. 'FFTransit Pict' font by **Erik Spiekermann,** published by FSI.

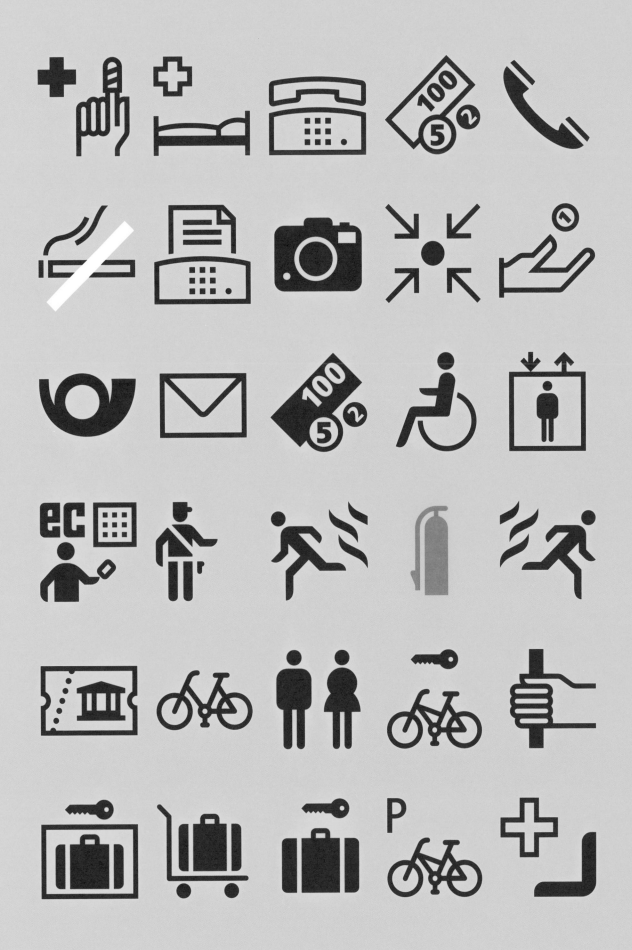

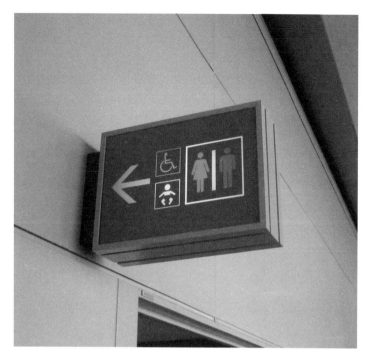

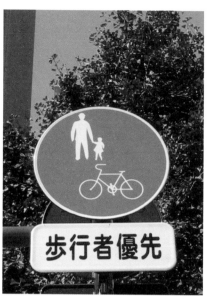

A selection of pictograms in public use. These symbols are learnt from an early age and rely heavily on this collective understanding. The politics of these symbols is often taken for granted. Consider for example, the international symbol for 'toilets' where gender difference is signified by western European dress codes and a western signification of colour.

Perhaps the most challenging signs for both designers and viewers are those that describe services rather than objects or directions – signs for things like 'Lost Property' or 'Car Rental' have to communicate the abstract notion of ownership, as well as the more concrete ideas. Lupton and Miller[3] provide an amusing illustration of the difficulties of misreading the ideogram for 'car rental' as 'car dreams of a key' when it is read as a pure pictographic sign. This illustrates the depth of the codification of the pictogram. They are learnt as a social skill alongside reading our native alphabet. In some cases our understanding of pictograms is tested to give us the authority to operate in certain roles – a driving test, for example, would understandably devote some time to our recognition of pictograms. These are not open signs where reading becomes an internalised pleasure, but an official industrial language that helps the world operate. Despite their international application, many of these signs are grounded in culturally specific conventions. Even the international signs for toilets are culturally specific. For example, the universally accepted symbols for male and female – with the addition of a skirt to differentiate gender – don't translate well into all cultures. It is a good example of the hidden politics of visual language, that international signs for man and woman refer explicitly to a Western dress code that is simply inappropriate in many parts of the world.

In the case of safety signs, the codification is understandably strict. The *UN Convention on Road Signs and Signals* in 1949 ensured a commonality to traffic signs across the world.

> *'With a view to ensuring a homogeneous system, the road signs and signals adopted in each Contracting State shall, as far as possible, be the only ones to be placed on the roads of that State. Should it be necessary to introduce any new sign, the shape, color and type of symbol employed shall conform with the system in use in that State.'*[4]

The *US Dept of Energy* has also turned to the pictogram to design a series of warning signs for buried nuclear waste. The material buried at the *Waste Isolation Pilot Plant (WIPP)* in the New Mexico desert will remain radioactive for 10,000 years. Our current international language, English, is based on an alphabet that is only 2000 years old. A panel of linguists, scientists, science-related writers and anthropologists concluded that there is no guarantee that it will still be in use in the future. As a solution they have opted for an arrangement of pictograms featuring the human face and the triangular 'radioactive' symbol to supplement a series of buried markers in seven alphabetic languages. The images show the decline in the toxicity of the material over time in an arrangement remarkably reminiscent of an *Isotype* diagram.

Above. Character from 'Pussy Galore' font by **Teal Triggs, Liz McQuiston and Sian Cook, WD+RU**, published in Fuse no. 12, 1995. WD+RU deliberately interrupted our expectations of the reading of gender-based pictograms such as the international toilet signs. Existing signs are altered by adding elements that refer to cultural stereotypes – in this case the 'hysterical female' (see also page 141).

3. **Lupton, E & Miller, A.** Design Writing Research – Writing on Graphic Design, London: Phaidon, 1999

4. **UN Convention on Road Signs and Signals**, Chapter III – Signs and Signals, Article 17.1

2

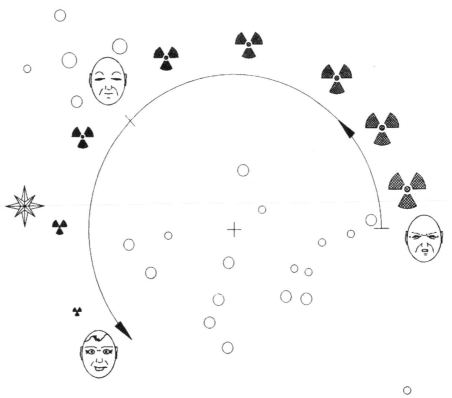

Opposite (Top). **NASA**. The message sent from Earth to Space on board the Pioneer 10 spacecraft.

Opposite (Bottom). **US Dept of Energy** WIPP warning markers. A series of warning signs for buried nuclear waste. The material buried at the Waste Isolation Pilot Plant in the New Mexico desert will remain radioactive for 10,000 years.

Above. **Susan Kare**, 'Bomb' icon designed for the Macintosh operating system, 1983.

Internationalism

5. **Kare, S.** www.kare.com/design_bio. html

6. **Jury, D.** TypoGraphic 64 – the National issue, Jan 2006

Pictograms are also undeniably economical. International traders rely heavily on the use of these pictorial signifiers to help distribute their products and services in a number of differing linguistic territories. Technical instructions and signals on a host of products allow global trade to avoid the costly business of manufacturing independently for each of their markets. This sense of internationalism extends beyond the practical and recognises the economy of message in communicating brand values through an industrial heraldry that draws on a similar metaphoric language of symbols. Pictogram designers are often tasked with bringing together the mood of a particular event or company with a set of instructional pictures. The results are a corporate identity exercise in symbolic communication where a balance has to be achieved between finding the most appropriate 'icon' and the most appropriate 'voice'.

One of the most international of products in recent years has surely been the desktop computer. The arrival of the *Apple Mac* in 1984, like all international products, needed a series of instructional pictograms. Susan Kare, who worked for Apple between 1983 and 1986, was given the task of transforming small grids of 30 x 30 pixels into a set of symbols that would help users operate the new computer. It was an exercise in 'searching for the strongest metaphors'[5] for a whole set of actions and commands. The result was a series of classic symbols, such as *'the trashcan'*, 'the spinning watch' and *'the bomb'*. It is a testimony to her skill as an interface designer that these icons are still with us today. The combination of common sense and humour generated a set of symbols that has successfully personalised the computer interface. The 'smiling Mac' face at start-up is as reassuring and affectionate now as it was when it was launched in the 1980s.

What all these examples have in common is that they provide a bridge between a technical world and reality. They help us to navigate a constructed landscape of things and places by supplying a pictorial equivalent of the ubiquitous *Helvetica*. They are a necessary adjunct for any society that plays a part in the globalisation of culture through consumption. Without them we are lost in a world of local customs, ambiguous signification and unique experience. Yet as David Jury commented:

'The last thing one wants to see on the streets of a foreign country is Helvetica.'[6]

Right. **Susan Kare**. A series of icons designed for the Macintosh operating system, 1983–86.

Below. **Jonathan Hitchin / Beaufonts**. Symbols designed to add individual character to software icons.

Below (Right). **Jonathan Hitchin / Beaufonts**. Interface design for the 'Image Bin', a virtual silkscreen print generator, 2002.

IMAGE BIN

06.0330

INFORMATION : GALLERY : DEMO :

Instructions getting started 1 : 2 : 3 prev : next

solid 01
solid 02
solid 03
solid 04
solid 05
GROUND

1 : Patch all image layers to the group controller. This means that all layers will be affected by any button clicks. Each layer has it's own patch button to add or remove it from the group control layer.

* open the image bin demo from **here** : requires **shockwave**

© 2002 Beaufonts

Converging Technologies

The Desktop Computer

1. **VanderLans, R** and **Licko, Z**. 'The New Primitives' I.D. magazine, USA, vol 35, no. 2, 1988

2. **Greiman, A.** Design Quarterly magazine no. 133, 1986

3. **Poynor, R.** No More Rules: Graphic Design and Postmodernism, London: Laurence King, 2003

Not surprisingly the introduction of desktop computing technology to the visual arts was met with suspicion. The entire design industry was founded on a set of established hierarchies – much like society itself – and the arrival of the 'Mac' in the late 1980s unsettled the status quo. Early reviews dismissed the technology by focusing on its crude visual output, but in the USA, where the Mac first appeared, Rudy VanderLans and Zuzana Licko experimented with the new technology with an enthusiasm that accepted the crude bitmapped output as part of a 'pioneer spirit'. As they stated in their essay *'New Primitives'*:

'Much of the scepticism and disfavour currently attached to digital images will disappear as a new generation of designers enters the profession…Having grown up with computers at home and school, these designers will assimilate computer technology into the visual communication process as it penetrates everyday practices.'[1]

April Greiman's ambitious life-size portrait (2ft x 6ft) in *Design Quarterly* magazine[2] in 1986 (see also page 114) was a celebration of the new digital technology. It carries the quotation from Wittgenstein, 'the sense lies far in the background'. You are left with the impression that Greiman is not in a hurry to analyse the image, that the viewers might find it for themselves. Rick Poynor draws our attention to the sheer excess of the poster – not only its size, but also the quantity of information and the volume of data. It suggested that design would use the new tools to explore a new direction. Arguably this poster crystallised the moment when graphic design moved away from its preoccupation with a set of principles that had their roots in modernism:

'For many designers, the point of design was still to eliminate extraneous information (noise), to thwart the possibility of ambiguity by reducing design to its essentials.'[3]

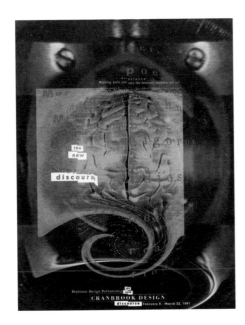

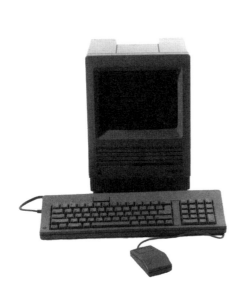

Above. **P. Scott Makela**.
The New Discourse. Poster
for exhibition, 1990.

Right. **April Greiman**. Poster
for Design Quarterly no. 133,
1986.

Below. The Apple Mac
Classic, 1984.

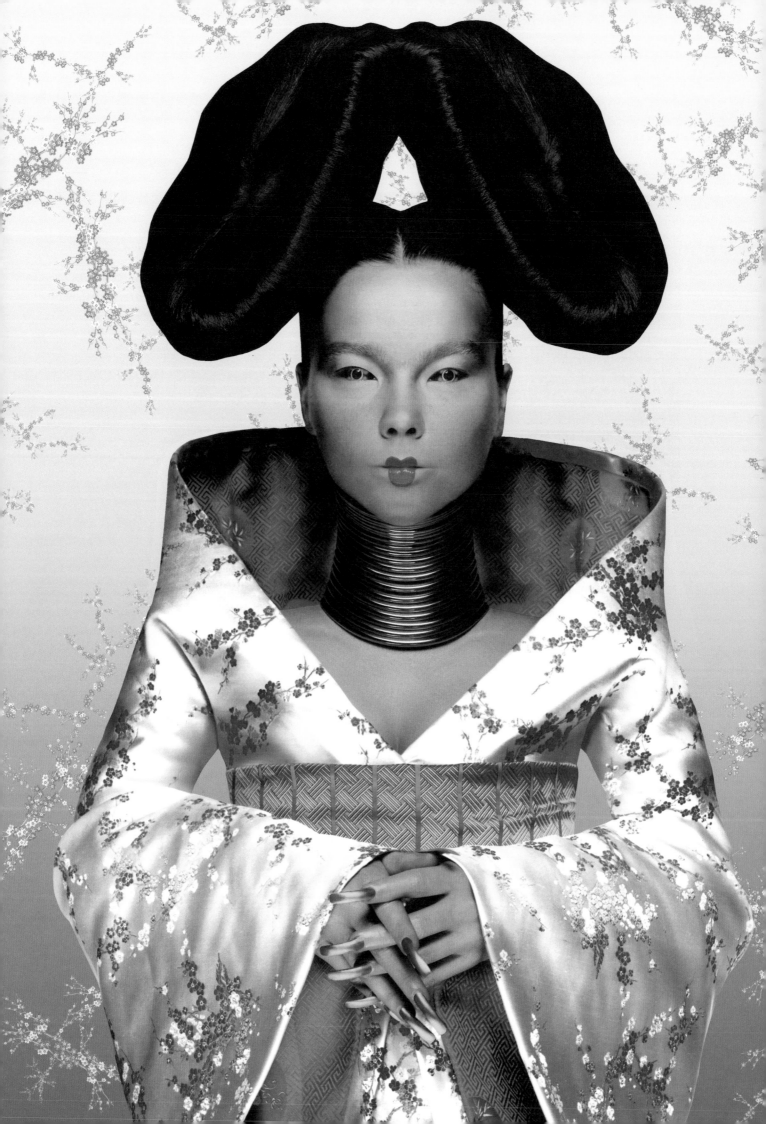

The 1990s saw an explosion of images, 'overwhelming' the viewer. In a clear rejection of the cool analytical attitude of the modernists', the new mood was all about the sensational experience offered by the new digital tools.

On both sides of the Atlantic, designers began to explore the new digital world with vigour, unfettered by graphic design tradition. P. Scott Makela in the USA was fascinated by the idea of information overload. His work was richly layered, dense with imagery and firmly rooted in televisual sensibilities. Rick Poynor[4] observed that although the source material was quite different, designers on both sides of the Atlantic shared in the celebration of the communications age and collectively their work could be considered an analogy for what was to become the worldwide web. Both sampled freely from what already existed, re-inventing the everyday and constructing new relationships. There were similarities to the work of the surrealists with their concentration on forging new meanings from what was around them. This 'remix' culture, what Malcolm Garrett once termed 'retrievalism', anticipates the idea of surfing the web. Everything has been made already, all one had to do was to make choices and re-combine the elements in new ways. The exuberance of these early designs was continued to the end of the 1990s by groups like Me Company in London, who created virtual portraits of their clients suspended in a hallucinogenic virtual space. Using 3D modelling software they created flawless hyper-real renditions of artists, such as Björk, that blurred the line between the real and the constructed.

The computer seemed to promise an end to established hierarchies and restrictions. The communication industry had been divided into very clearly defined, self-contained roles: typesetter, photographer, video director, animator, illustrator, graphic designer, typographer and so on. The new technology began to eat away at the barriers between these roles as the software took on the capability to handle a range of projects and provide some fluidity between them – what Eric Martin describes as a true 'metamedium'.[5]

4. **Poynor, R.** No More Rules: Graphic Design and Postmodernism, London: Laurence King, 2003

5. **Martin, E.** in **Greiman, A.** Hybrid Imagery: The Fusion of Technology and Graphic Design, London: Architecture Design and Technology Press, 1990

Opposite. **Me Company**. Homogenic by Björk. CD packaging, 1997.

6. **van Blokland, E** and **van Rossum, J.** LettError, Drukkerij Rosbeek, 2000

7. **van Blokland, E** and **van Rossum, J.** http://letterror.com/content/nypels/about.html

Opposite. **van Blokland, E** and **van Rossum, J.** LettError, Drukkerij Rosbeek, 2000. The software engine was used to create a series of flick books that function as brief animations on the trim edge of the book.
Below. Examples of spreads from the book.

For some designers, digital technology was an invitation to combine the visual with an interest in computer programming. Eric van Blokland and Just van Rossum at LettError brought together the apparently distinct worlds of programming and graphic design to produce a book that was programmed and designed by 'Python', a bespoke software engine designed by Just's brother, Guido van Rossum. A set of parameters was offered to the 'machine', including a palette of possible colours and the software generated the pages.[6] LettError blurs the distinctions between disciplines, not just within what we know as communication design, but beyond into software engineering.

'The machine is built from a large number of small programs (scripts). Some of the scripts generate the images, others gather the text and apply the typesetting instructions. Then there are more scripts to manage the flipbook animations and the secret image on the left side of the book, track the words marked for the index, number pages, etcetera.' [7]

Increasingly we can see that digital technology is becoming available as a single tool – first as a desktop box, then as a portable box. It is at once a typewriter, a retrieval device, a page layout engine, a photo-retouching tool, an edit suite, a recording studio, a television and a radio. Increasing portability has also brought new opportunities as the camera and the computer shrink in size and are coupled to telecommunications. Now everyone can be a photographer, director, illustrator, animator or a designer. Arguably this sets up a real challenge to the hierarchies of publishing that extend back to the introduction of mechanical printing and moveable type around 1447. Anyone can now publish their work instantly to a worldwide audience using a device that they can hold in one hand.

Technology as Catalyst

A critical factor in the development of writing and visual communication is their relationship with technology. As the printing press was introduced we find that the use of a steel style to engrave a matrix for moveable type had an effect on the letterforms themselves. The introduction of the camera as stills then later in televisual imagery changed our understanding of representation. The desktop computer changed both the availability of imagery and the way it looked. The reduction of images to pixels, for example, forced us to render graphic marks in quite a different way. The story of the history of writing shows us that this relationship between technology and visual language has always been a key factor. If we look back to ancient scripts we can see that the relationship with technology has always been influential. *Cuneiform* is a clear example of how writing developed as a result of the properties of the materials. *Cuneiform* or 'wedge-shaped writing' developed around 3100 BC in Mesopotamia. The stick used was cut into a triangular section and pressed into one side of a soft clay tablet. The tablet was then turned over and the other side was inscribed. Impressing a carved stick into clay rather than scratching was quicker, more accurate and made the clay tablets easier to handle and store as they produced no ridges around the marks. Cutting across wood grain on Easter Island gave rise to a script with no horizontal or circular marks and the shape of runes in northern Europe also shows that they were determined in part by the wood that was used as a ground.

Artists and designers have always had an approach to technological advance where they will experiment with new tools to create new artefacts and ideas that are beyond the intended use of the tools. Whether new tools are created for scientific use or to satisfy very practical needs, designers will use them to generate new means of representation. As a result, the development of visual language will simply not stand still.

Opposite. **David Crow.** Left to Right, emoticons made for Flux magazine, 2005. Imagery originally created using the text function on mobile phones is transferred into a letterpress block – the technology originally used to popularise the letterform in the 1700s.

context

Invading Languages

8. **Robinson, A.** The Story of Writing, London: Thames & Hudson, 1995

9, 10. ibid.

'Sign simplicity or efficiency in representing the sounds of a language cannot be the sole criteria of survival. If they were, Chinese characters would have disappeared in China and been replaced by an alphabet; and the Japanese would never have borrowed Chinese characters. Political and economic power, religious and cultural prestige and the existence of a major literature all play a part in the historical fate of a script.'[8]

In terms of ease and efficiency Europeans need to recognise around 52 alphabetic signs whereas the Japanese need to recognise around 2000 symbols or 'Kanji', and highly educated scholars would need to be familiar with around 5000. The Japanese also have two sets of phonetic scripts. In addition to 'Kanji', their name for the pictorial Chinese script, they also have 'Katakana' and 'Hiragana'. These are a simplification of some of the historic Chinese characters. Katakana is a formal script with some 46 signs, made mostly from straight lines. This is now used like italic and used for foreign names or adopted words. Hiragana is the more curved, informal script that also has around 46 signs. Robinson[9] recounts an interesting tale where practical and potentially dangerous situations during the Second World War prompted the army to reduce the number of Kanji to 1235 and had plans to reduce it further. However, at the same time the newspaper reports from the front were using obscure Kanji characters in the belief that it would carry a certain austerity and impress the reading public; a wonderful example of language as an instrument of the state.

Since the 1980s, the Roman alphabet has begun to 'invade' Japanese writing through advertising. One could think of this invasion as a dialect – referred to as Romaji – favoured by Japanese youth as a form of rebellion. The fact that it irritates their elders may well be a large part of why they use it. Although the Roman alphabet has a certain prestige in Japan, the readiness to adopt it may be borne out of disillusionment with a rigorous linguistic system and the traditions it represents.

'With the word "love" in Roman letters we can work that into a graphic design and it carries a kind of cuteness and charm. But the Chinese ideogram for "love", we couldn't put that on a kid's school bag.' Head of Product development Sony Japan 1984[10]

Japanese society has mixed views on the appearance of 'Romaji'. Some see it as an example of Japan's post-modernity while others see it as a threat to their culture and traditions. A shift in the use of language is often seen as a threat to the established order of a culture – language is closely bound to identity – and the invasion of one script on another is likely to be viewed as a threat to cultural identity.

Opposite. Public sculpture in Shinjuku, Tokyo.

Left. Detail from a flyer offering a 'flat rate' for a mobile phone talk plan.

The Mobile Telephone

When the mobile phone made its Hollywood debut in 1987, few of us could have foreseen the sheer proliferation of the device by the turn of the century. In Oliver Stone's *Wall Street* the mobile phone makes its debut as a symbol of Yuppie extravagance – a fundamental tool for the modern executive who is permanently at work. 'Money never stops' claims Gekko, the film's main character. Looking back at this early incarnation of the mobile phone, its size alone seems to negate any possibility of it becoming truly 'mobile'. Just where do you carry a handset the size of a large house brick? Nevertheless Gekko (Michael Douglas) swaggers through the movie with his phone. By his side is the young, impressionable Charlie Sheen whose descent into flagrant greed is epitomised by his acquisition of his very own mobile phone. In less than two decades, almost everyone has one. Primary school children play games on them, teenagers flirt with them, parents find them reassuring and grandparents use them to keep in touch with their grandchildren. The mobile phone is so embedded in our culture you hardly notice it's there anymore. Of course the object itself has shrunk in size considerably so it can now be concealed in the average sized hand. However, as it has reduced in size, it has grown in capability. The 'mobile telephone' is so much more than that now. It has been transformed into a hand-held entertainment and communication console for the 21st century. In addition to its obvious functions, the mobile has become a stills camera, a video camera, a fax machine, a sound recorder and an access point for the worldwide web. It has been used to provide evidence for prosecution in courtrooms and used to save lives. The recordings of the messages and calls from the twin towers on September 11th 2001 provide a chilling example of the intimacy of this medium. It can instantly transport us to another location and into another time zone. We receive the technological postcards a matter of seconds after they are sent. The mobile telephone has shrunk the world. Just as the previous generation did not know life without television, today's teenagers have not known life without the mobile phone. The so-called 'MTV generation' has been replaced by the 'M-Agers'.

The Mobile Telephone / Portable Identity

11. **Adams, M.** Experiments in mixed reality, Receiver magazine / Vodaphone, 2003

The addition of a camera to the mobile phone has had a huge effect on the availability of imagery. It has offered us a tool for the production of our identities that has all the ostensible signs of creativity yet is neatly wrapped up in a post-modern consumer culture. There is a striking similarity between the phone camera and the Victorian locket, the carrying of miniature family portraits, concealed discreetly against the body, along with a tactile element such as a lock of hair. A vibrating alert supplies a tactile experience as we send more images directly into the pockets of our loved ones.

> *'Technology often promises transcendence from real life, but it is eventually domesticated through its interaction with real bodies in real spaces.'*[11]

Phone-photos can also function as visual calling cards. Each of us can choose a soundtrack and a visual identity for our regular callers – a miniature televisual identity for each of our friends. Many of us choose images that are not the likenesses of the caller, but visual metaphors that describe some characteristic of them. Teenagers explore their own visual vernacular by 'celeb-ing' – communicating by sending an image of a celebrity. This relies on an agreement among their community about the characteristics of celebrities and can be either flattering or very critical. It is essentially a visual dialect that exists outside of the official culture of communication, even if only until it is recuperated by a smart advertiser. The transience of associated meanings in 'celeb-ing' not only guarantees that parents can't understand the code, but it roots the whole exchange in the here and now.

Top. An arrangement of
street posters advertising
the latest handheld console.

Above. A selection of
mobile phones on a Tokyo
market stall.

Right. **startmobile.net.**
A selection of downloadable
screen images, 2006.
Site design by John
Doffing, founder of Start
Mobile.

The worldwide web is awash with places for us to buy our small screen identities and associated soundtracks. A new generation of designers is focusing its energies in this area and are pushing the capabilities of miniature animation. As with all technologies, the new visual language is affected by what is achievable and an aesthetic evolves as the technology improves. The small file sizes generated by vector graphics have modelled the 'look' of digital animation for the mobile phone, but this is likely to be part of an evolutionary cycle that will get increasingly sophisticated over time. These designers are the 'new primitives' of our time. Art galleries are also seizing the opportunity to join in the possibilities the new telephones offer. Designers and illustrators whose work has graced printed ephemera and leisure-based graphics can now be sourced for downloadable imagery. The art world is involved too. A collaboration between *Britart* gallery and *Vodaphone* in 2001 offered eight works of 'new British art' as a downloadable edition at 36 pence each.

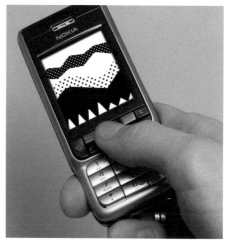

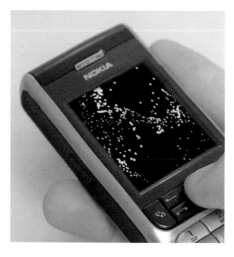

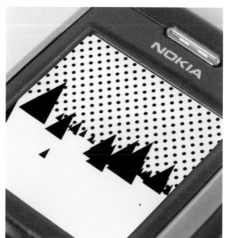

Right.
Universaleverything.com
A selection of downloadable screen animations, 2006. Design and animation by **Matt Pyke** at Universal Everthing / Audio by **Simon Pyke** at Freefarm / Production by **This is Real Art** / Client – **Contra / Nokia.**

Opposite.
Universaleverything.com
Japanese mobile phone movies, 2006. Design and animation by **Matt Pyke** at Universal Everthing / Audio by **Simon Pyke** at Freefarm / Client – **Motion Garage, Japan.**

The Mobile Telephone / Frontline Reporters

Recent news events in New York (9/11/01) and in London (7/7/05) brought an unexpected step in the evolutionary use of images captured on mobile telephones. An article in *the Guardian* entitled 'We are all reporters now' opens with the revelation from Helen Boaden (the *BBC's Director of News*) that within an hour of the London bombings they had 50 images available for transmission, all of them from the public. In this 'gear change' the UK watched the story unfold on their screens through a series of mobile phone photographs and video sequences. Some of the most powerful images of the event had come from the public and were captured on mobile phones. The *Ten O' Clock News* used two mobile phone video sequences to report the events of the day and a picture of the destroyed bus was on the *BBC* website within 45 minutes of the blast and was featured on the front cover of two daily newspapers the next morning. The same technology was used to turn the worldwide web into a giant message board posted with photos of the missing. As *the Guardian* observed, we are all frontline reporters now.

 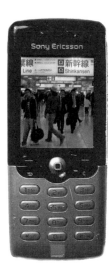

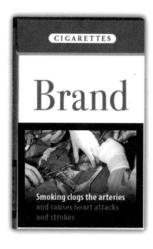 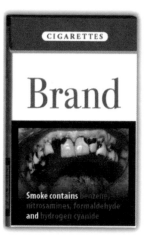 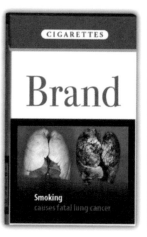 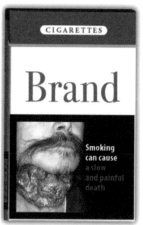

Amplifying Reality

12. **McLuhan, M.** in **Rosenberg, B.** and **Manning White D.** Mass Culture - The Popular Arts in America, New York: The Free Press, London:Collier MacMillan,1957

As Marshall McLuhan put it, television has the ability to 'amplify' reality.[12] Where previously we had relied on an account of current affairs in the form of a spoken narrative or a written text, we are now able to cross reference a number of different accounts that appear as first hand accounts. The combination of colour photography and broadcasting has brought us a perception of reality that is played out as eyewitness reports. The image has become accepted as 'proof' in a version of reality where the closed circuit television picture (CCTV) cannot be contested. What is considered 'real' no longer relies on actual first hand experience, but a on a photographic representation. We seem to trust pictures more than people. From the political intensity of the first moon landings to the banality of parking fines, the argument is settled with the photograph. Reality can be experienced as a 'spectacle' of images, accessible every morning in the newspaper and at any time on a screen. The arrival of new communication technologies has brought us the so-called 'globalisation' of culture. This is seen as the linking of types of activity as well as geographical regions. There are a number of definitions that suggest that it is not a single process but a combination of a number of different elements. It stretches social and political activities across world regions, intensifies our interdependence, speeds up transport and communication and ultimately means that distant events are able to have a much greater impact on our everyday experience. Local issues can take on a global proportion and the line between local and international issues becomes increasingly blurred. For example, the fight against third world poverty or specific human rights issues is given periodic injections of intensity when images of suffering are broadcast in the west. In such circumstances an emotional response to the photographic image is undeniable. Moments of reality appear to take on epic proportions as they materialise in our homes amongst our daily experience. The most emotional and effective responses appear to have a direct relationship with the strongest combinations of visual signs.

The effectiveness of graphic photography has been acknowledged by The Department of Health in the UK who have recently announced plans to introduce images on to cigarette packs. Proposed images include diseased lungs, a dying smoker and a foetus in the womb. The final images will cover 40% of the back of packets sold from autumn 2007. The Canadian government introduced health warnings in 2001 that were accompanied by colour pictures. Not surprisingly the size of the warnings had an effect on the effectiveness of the message but the most effective warnings were those that featured colour photographs. Cancer Research UK have tested the Canadian images and found that they are equally effective with a European audience. Health Secretary Patricia Hewitt, said: 'These messages become less effective over time so we now need to refresh our approach by introducing new hard-hitting images.' Jean King, Cancer Research UK's director of tobacco control, said: 'The evidence from Canada, Brazil and elsewhere is clear - graphic picture warnings inform people of the risks of smoking and help encourage people to reduce their smoking or quit altogether.'

Opposite Top: Our daily experience is documented with ease using the combined technology of the camera with the mobile telephone. This has had a huge effect on the quantity of images available that describe news events.

Opposite Bottom: A selection the images proposed by the Department of Health as warnings on cigarette packs in the UK from autumn 2007.

context

SMS / Short Messaging System

13. Source – Keynote Ltd.

14. **Locke, M.** Light touches – text messaging, intimacy and photography, Receiver magazine / Vodaphone, 2003

15. **Locke, M.** Light touches – text messaging, intimacy and photography, Receiver magazine / Vodaphone, 2003

16. **FF PicLig** – FontShop International

17. **Wilson, A.** Text Messages, Huddersfield: Smith / Doorstop Books, 2003

Opposite Top.
'FF PicLig' font by **Christina Schultz**. Published by FSI, 2005.

Opposite Bottom.
Andrew Wilson. 'I-Kee-Ya' from 'Text Messages', 2003. Technology influencing cultural language, in this instance through the restriction of a message size caused by available bandwidth.

Overleaf Left. **Richard Bowater**. SMS texts. Soliloquy from 'Hamlet' by William Shakespeare and Martin Luther King 'I have a dream', 2002.
Overleaf Right. 'FF PicLig' font by **Christina Schultz**. Published by FSI, 2005.

SMS was essentially an afterthought in the development of mobile phone technology, spare space on the bandwidth. This afterthought has become the most popular method of communicating for today's teenagers, as it is considerably cheaper and more discreet than a regular 'call' and although users are taking photos, not all of them can afford to send them regularly. Currently in the UK there are in excess of 25 million text messages sent each day, rising to a staggering 40 million on St Valentine's Day. At current rates of growth the forecast[13] for the UK is 14 billion SMS messages for the year 2009. Although texting is ostensibly based in the culture of words it is evolving to form its own grammar, its own words and is becoming increasingly visual through the construction of 'emoticons' – pictures created using alphabetic letterforms. Manufacturers soon grasped this and included pictorial signatures that can be added to a text message from a pre-set menu. Like the metaphoric photograph, texting allows the users to operate in a visual space outside of the official avenues:

'…texting also gives space to intimate, private languages that are impossible to capture on the public surface of the photograph. The vernacular grammar of text messaging developed partly as a response to its limitations, but also to its intimacy, mimicking the childish languages of lovers. The text message is a note passed from hand to hand in a classroom, a secret rather than an announcement.'[14]

One of the most intriguing SMS phenomena is the 'empty SMS message', a craze that appears to have started in Japan. The sender simply communicates a blank screen to the recipient as a quick 'hello'. It is economic, both semantically and monetary, and functions with an understanding among the linguistic community that it is not simply a mistake. It says, 'I thought of you', without the overlaid conventions of social discourse. It lasts only a moment. It is immediate and sensory: a momentary sensory buzz in your pocket that announces its arrival – 'hi!'. It is what Matt Webb[15] describes as a 'stroke', the minimum unit of social relation. Typographers and writers have also explored SMS as an expressive medium. The arrival of 'open type', with its multiplicity of options within each font, has given typography an opportunity to extend the alphabetic lexicon a font contains to include a range of symbols and icons that have grown out of the creative use of text messaging. In FF PicLig[16], for example, the users can employ the sub-menu to convert the combination of the letter 'D' and two arrows '>>' to form an icon of a mobile phone in a contemporary interpretation of the traditional typographic ligature. In poetry, Andrew Wilson has experimented with SMS in his book *Text Messages*.[17] The poems are restricted by the technology with a 160-character limit and the results are impressions of fleeting moments of experience, not unlike the Japanese form of poetry known as 'haiku':

I-KEE-YA

We follow arrows
On the path
Between the dolls house rooms:
a Madame Tussauds
of the people wed like to be.

HMLT

Ntr Amlt

2b, or NTB, Tht s T?
Wthr Ts nbla in T mnd 2 sufa
T sings & arws of otragus 4tne,
Or 2 tk rms agnst AC of trubs,
& by oposn nd thm, 2 dy, 2 slp- 60
No mor; & by a slp 2 sa we nd
T hrt-ak & T 1000 ntrl shks
Tht flsh S her 2 - 'ts a cnsmatn
Dvoutly 2b wshd. 2 dy, 2 slp
2slp, pchnc 2drm. Ay, thrs T rb 65
4n tht slp of dtn whf drms ma cum,
Whn we hv shfld of ths mrtl coil,
Mst gv us paus. Thrs T respct
Tht mkscalmty of so lng lfe,
4hu wld ber T wips & scrms of tm' 70
Toprsrs wrng, T prd mns cntmly,
T pngs of dsprzd lv, T lw's dlay,
T inslnc of ofic, & T spns
Tht patnt mrt of th'nwrthy tks,
Wen he hmslf mit hs qits mak 75
Wth a bar bdkn? Hu wuld frdls ber,
2 grnt & swet undr a wery lfe,
Bt tht T dred of smthng aftr deth,
T undscvrd cuntry frm huse burn
No travler rtrns, puzls T wil, 80
& mks us rther ber thos ils we hav
Thn fly 2 othrs tht we now not of?
Ths consinc dus mak cwrds of us al,
&ths the ntiv hu of rsolutn
Is sikuld oer wth T pal cst of thort, 85
& entrprses of grat pthc & momnt
Wth ths rgard thr curnts trn awry
& lus T nme of acton. Sft u now,
T far Ofela. -Nmf, in thy orsns
B all my sins rmemberd. 90

Mrtin Lthr Kng, Jr.

28th Aug 1963, Wshngtn D.C.

i hv a drm tht 1 da ths natn wil ris up & liv out
T tru menng of ts cred: We hld ths trths 2b slf-evidnt
tht al mn r crated =.

i hv a drm tht 1 da on T red hls of Gorgia T sns of frmr
slv ownrs wil b abl 2 st dwn 2gthr @ T tbl of brthrhud.

i hv a drm tht 1 da evn T stat of Misisipi, a stat sweltrng
wth T het of injstls, sweltring wth T het of opreson, wil
b transfrmd in2 an oass of fredm & jstis.

i hv a drm tht my 4 ltl chldrn wil 1 da liv in a natn wer
thy wil nt b jdged by T culr of thr skn bt by T contnt of
thr caractr. i hv a drm 2dal

i hv a drm tht 1 da, dwn in Albama, wth ts vicus racsts,
wth ts gvnr hvng is lps drpng wth T wrds of intrpsitn
& nlificitn; 1 da rit dwn in Albama ltl blk bys & ltl blk grls
wl b abl 2 join hnds wth ltl wit bys & wit grls as sstrs &
brthrs. i hv a drm 2dal

i hv a drm tht 1 da evry valy shl b exltd, & evry hl &
mntin shl b mad lw, T ruf plcs wil b mad plan, & T crukd
plcs wil b mad strat, & T glry of T Lrd shl b revled & al
flsh shl c it 2gthr.

Ths is our hop. Ths is T fath tht I wl go bk 2 T Sth wth.
Wth ths fath we wl b abl 2 hw out of T mountn of dspar
a ston of hop. Wth ths fath we wl b abl 2 trnsfrm T
jnging dscrds of our ntn in2 a butifl smfony of brthrhud.
Wth ths fath we wl b abl 2 wrk 2gthr, 2 pry 2gthr, 2
strugl 2gthr, 2 go 2 jal 2gthr, 2 stnd up 4 fredm 2gthr,
nowng tht we wl b fre 1 da. & ths wil b T da, ths wil b
T da wen al of Gds chldrn wil b abl 2 sng wth new menng,
"My cntry 'ts of Te, swt lnd of lbrty's prid, frm evry
mountinsid, lt fredom rng!" & if Amrica is 2 b a grat ntn,
ths mst bcum tru.

& so lt fredom rng -- frm T prodigus hlltps of Nw Hmpshr.

Summary

context

180

Summary / The Analytical Image

In the shift toward images, we can see a development
that has grown from two quite different sources,
generating different types of pictures. They are
not differentiated by the tools used to create the
images, or by the media used to publish them.
Their distinction lies deeper in their underlying
sensibilities.

On the one hand we have the legacy of the modernist
designers: passionate about improving the world
through communication and keen to establish a
discourse to understand how communication works.
This is a 'discursive' world, rooted in an academic
landscape where words are the recognised carriers
of knowledge, rich in detail, linear in structure
and abstract in nature. Modernism celebrates the
machine and often develops an aesthetic around that
which draws our attention to the media itself.
It is a world of analytical interpretation,
according to Leonard Shlain/1, an activity located
in the left side of our brain: the side more
developed amongst men.

In the 1960s, Roland Barthes/2 pointed us to the
constructed images of advertising as an ideal place
to practice how to 'read' images. The desire of the
advertisers to get clear messages, uninterrupted by
the noise of uncertainty, offers us straightforward
interpretation. In a period of post—war optimism and
economic growth, the advertising industry grew to
maturity and with it came an increase in the volume
of images for us to consume. As our perception of
the world is directed to (largely photographic)
representation as much as to reality we become
increasingly sensitised to question what is real.

In the world of letters and words, the renewed
enthusiasm for 'protowriting' illustrates that a
shift toward the pictorial is also happening in the
mechanical notation of language. The need to find
common linguistic territory has been heightened
through 'electronic' travel and globalisation.
The global commodification of culture demands a
shared approach to language to sustain it and the
legacy of Neurath and Isotype is that we are now
able to navigate ourselves through a whole range of
practicalities across national boundaries. In the
work of Charles Kasiel Bliss/3 an entire section of
our societies has finally found a means of
communicating in a meaningful way. Although
Neurath, Bliss and their associates may fall short
of some of their original aims, their work is a
significant achievement and an essential part of
what makes the global village possible. The
protowriting that grew from the modernist principles
of the mid-20th century has a very different
sensibility to the experimental fonts from the
typographers of the 1980s and '90s. Neville Brody's
Freeform font/4 may share some alphabetic qualities
with Helvetica or Neurath's Isotypes, but it is
much more grounded in Sontag's notion of art as a
'sensory' experience/5. The typographers that
inherited the 'Mac' withdrew from an alphabetic
and essentially linear structure and introduced the
possibilities of a new relationship with our
alphabet. In some cases this work was clearly
indebted to modernist principles and they created
new sets of symbols, more relevant to the mood of
the time, and tested the conventions of the graphic
icon. For others it was an invitation to use a
keyboard to paint and draw in an exciting mix of
poetic expression and mass production.

Summary / The Sensory Image

As a contrast we have the post-modernist view of
the world as a sensory world: putting experience
before analysis. Unbridled from the need to
continually expose the 'subtext', the post-modernist
experiences life as a network of signifiers. Their
sensibility is 'figural' as opposed to 'discursive',
and their approach is 'holistic' rather than
'analytical'. This functions on the right side of
our brain: the feminine side according to Shlain/6.
These post-modern image-makers have come from a
generation who have always known life with the
television, the desktop computer, the games console
and the mobile phone. They have witnessed an
increasing fluidity between these technologies and
recognise the screen, however small, as a window in
which the world is played out in RGB. Scott Lash
points out that what we are perceiving, in TV, in
video, in the spread of information technology, on
our i-Pod, DVDs, in advertisements, in magazines
are iconic representations of reality, images.

**

'These representations come to constitute a very
great proportion of our perceived reality. And/or
our perception of reality comes to be increasingly
by means of these representations.'/7
///
He continues that the post-modern experiment is:

'with the problematic nature of reality and the
relationship of reality to representation.'/8
**

context

The trend towards what has been called 'ambient advertising' is a good example of this. The use for example of graffiti teams, spray-painting stencilled imagery and logos in city centres begins to blur the line between what is a representation of youthful rebellion and the real thing. One begins to doubt whether graffiti can have any real value as a medium of resistance to commodification when it becomes impossible to tell who is copying whom. This problematisation of reality was eloquently described at a meeting I attended recently where a director of an advertising agency calmly stated that 'news' is the new advertising.

Summary / Technology as a catalyst

Throughout the history of language, cultural shifts can be demonstrated to have a direct relationship with technological and social change. It seems reasonable to assume that the shift towards the 'image' is no different. The arrival of television, coinciding with the end of the Second World War, had a profound effect on visual language. The rapid development of digital technology during the latter half of the 20th century accelerated what television had begun. The new media offered us not only the perfect vehicle to immerse ourselves in representations of reality, but also increased our interaction with other cultures. The end of the war shook up existing hierarchies and increased mobility between established class systems, cultures and careers. This democratisation of culture has been reinforced by the development of digital technologies.

According to McLuhan/9, the technical characteristics of printing, photography, film and television all enlarge our experience and our possibilities for expression. He proposes that a reliance on text created the solitary student and encouraged a private interpretation rather than a shared public experience. It established a divorce between literature and life, what Susan Sontag/10 described as 'the revenge of the intellect upon the world'. Perhaps then, it is the post-modern sensibility for 'experience' as opposed to 'interpretation' that made television so appealing and moved magazines to be an entirely pictorial experience based on single word themes. McLuhan/11 suggests we remember that the real power of images comes from the fact that the camera and the projector resemble the human process of cognition more closely than the alphabet. Shlain/12 suggests that as we seem to have shaken ourselves free of the 'linear aspects of literacy' we are now able to look back on them, and reflection might be seen as an end to change. Inevitably one is left wondering where this might eventually lead us. Visual communicators are still struggling with the search for some form of purpose to what they do just as Otto Neurath was almost a century ago. The desire among many graphic designers to unshackle themselves from commodification has never fully materialised. Just as Otto Neurath's desire for a utopian outcome for his work was compromised to become the founding principle for a much more prosaic purpose, one can see that although pictorial communication may not in itself be a commodification, it can certainly be commodified. Any attempt to answer the question of where the future of visual communication might lie would have to start with an approximation at the future capabilities of technology. It is likely

that it is technological change that will be the main catalyst for changes to visual culture.

It is also likely that alphabetic language will prove to be as flexible in the future as it has been in the past. It is the flexibility of the English language, its ability to adopt new words and new meanings that has enabled it to become the international language. As long as new words from the world of business and technology are added to our vocabulary, then it is hard to imagine that the utopian dream of a pictorial replacement for the alphabet will ever fully materialise. In the UK, young 'texters' have replaced the word 'cool' with the word 'book', as this is the first option offered by predictive text. It is quicker than making corrections and is now understood by their peers as a new term — so much so that it has now become part of their everyday conversational speech. Typographers, whose raw material is the alphabet, are also responding to the challenge of the new 'virtual reality' of the digital age. Our relationship with our alphabets is being explored using typographic software so that the very act of typing is infused with the sensation of uncertainty and entertainment. In the excitement of the possibilities of the visual sensation that the computer offered, a generation of designers seem to have forgotten about the sensation of 'touch'. For some time, so much attention was given over to the virtual space and the capability of the 'machine' in manipulating images, that everything seemed to have the same physical properties. The recent revived interest in tactile processes, like letterpress for example, suggest that the next generation of designers has begun to integrate all the senses in what might become a truly holistic

communication. Although the promise of 'virtual
reality' has not yet fully materialised, one might
expect that designers who can manipulate all the
senses with their new technological tools will be
best placed to push design forward.

In an educational context, we have seen a gradual
change in the way that art and design justifies its
place in our societies. The world of education has
demanded lengthy dissertations to prove our worth,
and until very recently it has avoided the full
integration of visual media in this process. In
what seems like the kind of reflection that Shlain
is hoping for, we now have signs that we are
becoming more receptive of the new. One regularly
hears schools and universities complain of falling
standards in reading and writing from a generation
of students who grew up surrounded by computer
game consoles and mobile phones. Whether this is a
lowering of standards or merely a redefinition of
standards is a debate that is likely to continue
unresolved. Against a backdrop of complaints about
the poor grammar of our students, the former
chairman of the Booker prize John Sutherland, is
pioneering summaries of classic literature available
as a text message download. On the global campus
some universities have begun to offer online
seminars that resemble a television chat show and
in our High Streets we have art galleries without
walls. Whether change is for better or for worse,
it is undeniably exciting to watch. The irony that
these ideas are outlined as a written text is not
lost, however, the trend of mass-media communication
is unmistakably toward the visual and we find
ourselves in an age where even our written language
is becoming more and more visually driven :-)

**

context

1/Shlain, L. The Alphabet Versus the Goddess: The
Conflict Between Word and Image, New York: Penguin
/Arkana, 1998

2/Barthes, R. Elements of Semiology, Cape, 1968

3/Blissymbolics Communication International (BCI)
www.blissymbolics.us

4/Neville Brody. Fuse 10 — Freeform, 1994

5/Sontag, S. Against Interpretation, London: Eyre &
Spottiswoode, 1979

6/Shlain, L. The Alphabet Versus the Goddess: The
Conflict Between Word and Image, New York: Penguin
/Arkana, 1998

7/Lash, S. Sociology of Postmodernism, London and
New York: Routledge, 1990

8/ibid.

9/McLuhan, M. in Rosenberg, B and Manning White, D.
Mass Culture — The Popular Arts in America, New
York: The Free Press, London: Collier MacMillan,
1957

10/Sontag, S. Against Interpretation, London:
Eyre & Spottiswoode, 1979

11/McLuhan, M. in Rosenberg, B and Manning White,
D. Mass Culture — The Popular Arts in America,
New York: The Free Press, London: Collier MacMillan,
1957

12/Shlain, L. The Alphabet Versus the Goddess:
The Conflict Between Word and Image, New York:
Penguin /Arkana, 1998

**

context

Bibliography

Adams, M. Experiments in mixed reality, Receiver magazine/Vodaphone, 2003

Baines, P. Penguin By Design, London: Penguin Allen Lane, 2005

Barthes, R. Elements of Semiology, Cape, 1968

Barthes, R. Image, Music, Text, London: Fontana, 1977

Barthes, R. Rhetoric of the Image, New York: Hill and Wang, 1977

Blackwell, L. 20th Century Type, London: Laurence King, 2000

Bourdieu, P. Language and Symbolic Power, Cambridge: Polity Press, 1991

de Saussure, F. Course in General Linguistics, 1974 (first edition 1915) Fontana

Dreyfuss, H. Symbol Sourcebook: An Authoritative Guide to International Graphic Symbols, New York: John Wiley & Sons, 1972

Dzamic, L. No-Copy Advertising, Switzerland: Rotovision, 2001

Eco, U. The Search for the Perfect Language, Oxford: Blackwell, 1995

Elkins, J. The Domain of Images, Ithaca and London: Cornell, 2001

Evamy, M. World Without Words, London: Laurence King, 2003

FF PicLig – User's guide, FontShop International

Frutiger, A. Signs and Symbols, New York: Watson-Guptill Publications, 1997

Frutiger, A. Type, Sign, Symbol, Zurich: ABC Verlag, 1980

Garland, K. A Word in Your Eye, Reading: University of Reading, 1996

Greiman, A. Design Quarterly magazine no. 133, 1986

Greiman, A. Hybrid Imagery: The Fusion of Technology and Graphic Design, London: Architecture Design and Technology Press, 1990

Jury, D. TypoGraphic 64 – the National issue, Jan 2006

Kare, S. www.kare.com/design_bio.html

Keynote Ltd.

Lash, S. Sociology of Postmodernism, London and NewYork: Routledge, 1990

Levi-Strauss, C. The Elementary Structures of Kinship, Boston: Macmillan, 1969

Locke, M. Light touches – text messaging, intimacy and photography, Receiver magazine / Vodaphone, 2003

Lupton, E & Miller, A. Design Writing Research – Writing on Graphic Design, London: Phaidon, 1999

McLuhan, M. The Medium is the Message, London: Bantam Books/Random House, 1967

Neurath, O. International Picture Language, London: Kegan Paul, Trench, Trubner & Co., 1936

Neurath, M. What is Electricity?, Parrish, 1964

Neurath, M. What's New in Flying?, Parrish, 1957

Neurath, M. Fire, Parrish, 1950

Neurath, M and **Lauwerys, J.A.** How the First Men Lived, Parrish, 1951

Ota, Y. Pictogram Design, Tokyo: Kashiwa Shobo, 1987

Poynor, R. No More Rules: Graphic Design and Postmodernism, London: Laurence King, 2003

Rand, P. A Designer's Art, Yale University Press, 1985

Robinson, A. The Story of Writing, London: Thames & Hudson, 1995

Rock, M. 'Beyond Typography', Eye Magazine, No. 15, Vol. 4, 1994

Rosenberg, B and **Manning White, D.** Mass Culture – The Popular Arts in America, New York: The Free Press, London: Collier MacMillan,1957

Rotha, P. Future Books Vol. 2–10, from Hieroglyphics to Isotypes, Future Books, 1947–55

Saville, P. Designed by Peter Saville, London: Frieze, 2003

Seward Barry, A.M. Visual Intelligence – Perception, Image, and Manipulation in Visual Communication, New York: State University of New York Press, 1997

Shlain, L. The Alphabet Versus the Goddess: The Conflict Between Word and Image, New York: Penguin / Arkana, 1998

Sontag, S. Against Interpretation, London: Eyre & Spottiswoode, 1979

Triggs, T. The Typographic Experiment: Radical Innovation in Contemporary Type Design, London: Thames & Hudson, 2003

Twyman, M. Graphic Communication Through Isotype, Reading: University of Reading, 1976

UN Convention on Road Signs and Signals, Chapter III – Signs and Signals, Article 17. 1

van Blokland, E and **van Rossum, J.** LettError, Drukkerij Rosbeek, 2000

van Blokland, E and **van Rossum, J.** http://letterror.com/content/nypels/about.html

VanderLans, R and **Licko, Z.** 'The New Primitives' I.D. magazine, vol 35 no. 2, 1988

Wilson, A. Text Messages, Huddersfield: Smith / Doorstop Books, 2003

Wozencroft, J. The Graphic Language of Neville Brody, London: Thames & Hudson, 1988

Index

Acknowledgements

/ Picture Credits

Picture research by Seel Garside who has been invaluable

I would like to thank the following people for their support and their patience: Wendy, Drew, Ailsa and George Crow / Judy and Frank Pennington for always being around to help / Maureen Wayman, Steve Hawley, Neil Grant, Sue Bailey, John Hewitt, Lesley Nixon, John Davis, John Crabtree, Cen Rees and Tony Richards at Manchester Metropolitan University / Seel Garside, Mike O'Shaughnessy and Jonathan Hitchin at Liverpool John Moores University / Brian Morris and Natalia Price-Cabrera at AVA Publishing SA / A special thanks to the contributors – Chris Bigg / Erik van Blokland / Neville Brody / Marion Deuchars / Paul Elliman / Fontshop International / Adrian Frutiger / Malcolm Garrett / April Greiman / Laurie Haycock Makela / Jonathan Hitchin / Susan Kare / Me Company / Ian Mitchell / Vaughan Oliver / Rick Poynor / Universaleverything.com / Peter Saville / Startmobile.com

27–28. Images reproduced courtesy of Design Council Slide Collection at Manchester Metropolitan University, UK, copyright Design Council

37. B+H Ads, Collett, Dickenson and Pearce, Rain and Pyramids reproduced courtesy of Gallaher Ltd. and the History of Advertising Trust Archive

41. Benetton Ad – Newborn Baby
September 1991 © Benetton Group S.p.A. 1991 – Photo: Oliviero Toscani

41–42. Colors Magazine/NB.13/No Words, reproduced by courtesy of Fabrica S.p.A

44. The *Guardian*
Eyewitness – US Soldiers Playing Monoploy In Iraq, The *Guardian*, 09 December 2005 ('the Content') Copyright Guardian Newspaper Ltd. 2005

44. The *Guardian*
Eyewitness – Pakistan Earthquake Victim Operation, The *Guardian*, 12 October 2005 ('the Content') Copyright Guardian Newspaper Ltd. 2005

47–51. Penguin paperbacks courtesy of Penguin Group Ltd.

54. Rosetta Stone image courtesy of The British Museum

57. IBM Paul Rand Rebus 1981 poster, reproduced courtesy of IBM Corporation

59–83. Isotype Images. All images reproduced courtesy of Otto and Marie Neurath Isotype Collection, Department of Typography & Graphic Communication, © The University of Reading

85–89. Blissymbolics copyright Blissymbolics Communication International

91–99. Images reproduced by kind permission of Adrian Frutiger

142. 08/23/1966 'First View of Earth from Moon' – the world's first view of Earth taken by a spacecraft from the vicinity of the Moon. The photo was transmitted to Earth by the United States Lunar Orbiter I and received at the NASA tracking station at Robledo De Chavela near Madrid, Spain. This crescent of the Earth was photographed 23 August 1966 at 16:35 GMT when the spacecraft was on its 16th orbit and just about to pass behind the Moon. Creator/Photographer: NASA

143. Mushroom Cloud – the mushroom cloud seen from an American aircraft. Image reproduced courtesy of the Nagasaki Atomic Bomb Museum

151–153. Computer icons courtesy of Susan Kare

157. 'The New Discourse' reproduced by kind permission of Laurie Haycock Makela

158. Björk – Homogenic album cover. Courtesy of Me Company

169. Screen shots http://www.startmobile.net
design John Doffing, founder of START MOBILE

170–171. universaleverything.com – Mobile animations site credits for Nokia:
Design and animation – Matt Pyke at Universal Everything
Audio – Simon Pyke at Freefarm
Production Company – This Is Real Art
Client – Contra / Nokia

credits for Japanese mobile movies
Design and animation – Matt Pyke at Universal Everything
Audio – Simon Pyke at Freefarm
Client – Motion Garage, Japan

175. SMS poetry, Wilson, A. 'Text Messages', Huddersfield: Smith/Doorstop Books, 2003

All additional photography by the author except:
Tony Richards pp. 31, 33, 34, 35, 36, 160, 161
John Crabtree pp. 157, 162, 166, 172

Cover photograph by John Crabtree